# absinthe
# sip of seduction

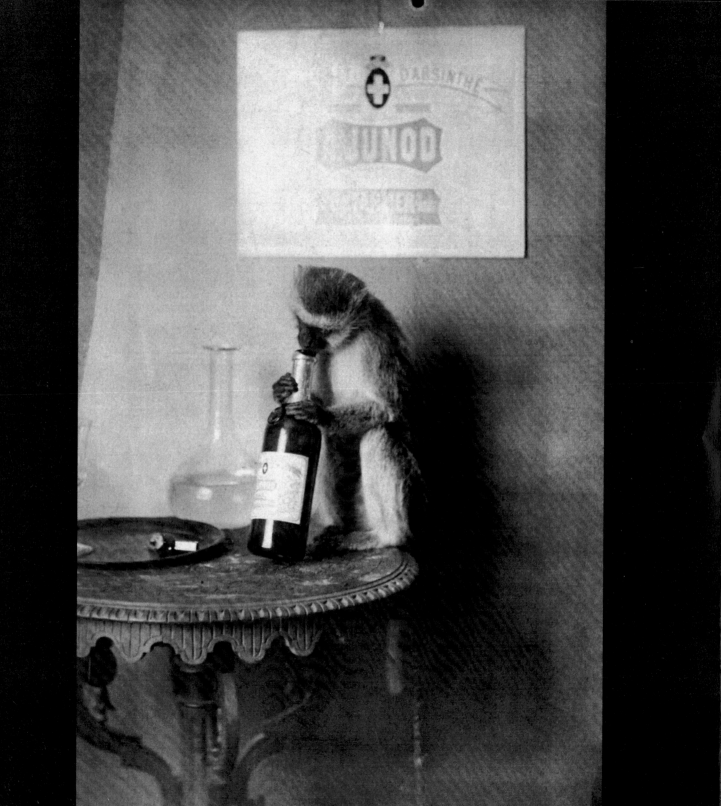

# absinthe
# sip of seduction

## betina j. wittels and robert hermesch

edited by t. a. breaux

foreword by marie-claude delahaye

CORVUS PUBLISHING | DENVER

Published by: Corvus Publishing, PO Box 102004, Denver, CO 80210

Book layout and design by Jerad Walters
Art Direction & Cover Design by Margaret McCullough

Printed and bound in Canada

Library of Congress Cataloging-in-Publication Data

Hermesch, Robert.
    Absinthe, sip of seduction : a contemporary guide / by Robert Hermesch and Betina J. Wittels ; edited by T.A. Breaux.
        p. cm.
    Includes bibliographical references and index.
    ISBN 0-9725776-1-0 (pbk. : alk. paper)
1. Absinthe. 2. Drinking customs -- Europe -- History. I. Wittels, Betina J. II. Breaux, T. A. III. Title.
TP611 .H47 2003
641.2'55--dc21
                                                    2003014566

10 9 8 7 6 5 4 3 2 1

## DEDICATIONS

I could never even whisper that this book was inspired by me alone. Adventurous as I am, this book would have never come to exist without the beings named hereafter. Besides the Green Fairy, who literally flung me into her realm and traipsed next to me through more than several continents, barrios, pueblos, bodegas, brocantes, markets, and villages, are those who led, nudged, comforted, taught, and helped me in every possible way. To these friends, mentors, customers, associates, collectors, dealers, and guides, I offer my humble gratitude.

—Betina J. Wittels

Special thanks to my family, for their love and support; Kevin Hart, for putting me on the path; George Phocas, for his enthusiastic guidance; and Kevin Morrin, whose gift from Europe got this train wreck moving in the first place.

—Robert Hermesch

## ACKNOWLEDGMENTS

Michelle Baldwin, Kirk Barrett, François Bezençon, T. A. Breaux, Philipe and Catherine Brun, Paolo Castellano, Martin Catbill, John Ciulla, Tony Ciulla, Kathleen Cole, Josep Comas, Patrice Cordier, Bernard Cousin, Ross Crockford, Michel Cuenot, Damien Delabre, Marie-Claude Delahaye, Melissa Dishell, Andrew Dudinsky, Peter Ellis, Rodrigo Ferreira, Jennifer Gjestson, Stephanie Guedon, Winston Guthrie, François Guy, Sean Haney, Harold Haney, Michael Iavarone, Parisot Jocelyn, Kath from Sixtina, Derek Lawrence, Brian Lewandowski, Donald Livingstone, Eric Longuet, Andrea Martin, Jean-Philippe Martinez, Mark Meloche, Ramon Montané, Jean Nevet, Susan Hill Newton, Jim Nikola, Benoît Noël, Dan Noreen, Fred Pahl, Simon Pedersen, Father Patrick J. Perez, Gerard and Odile Pernot, George Phocas, Mike Prayter, Rebecca Prince, Eric Przygocki, Joel Rane, Steve Rosat, Ana Streczyn, Tabu Absinthe, Monica and Claude Talluel, Tracy Thomas, Jörg Tragert, Nicolas Tripet, Jack Truten, Eric Vreede, Dita Von Teese, Charly Walburger, Jerad Walters, Matthias Wohlwend, God, and The Green Fairy

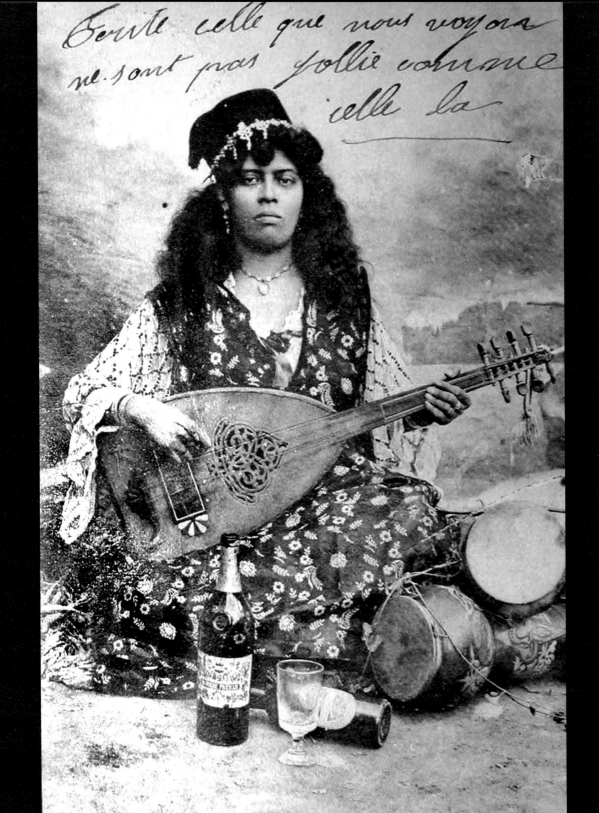

Toute celle que nous voyons ne sont pas jollie comme celle la

# CONTENTS

(Opposite) The handwriting on this postcard promoting Rivoire Absinthe says, "all the girls we see are not as pretty as this one."

# FOREWORD

## MARIE-CLAUDE DELAHAYE (*Trans. by Father Patrick J. Perez*)

*I* started collecting absinthe objects only by accident. In a flea market, I found a lovely pierced spoon and the vendor said the magic words, "It was used for absinthe," which served as a veritable open sesame into the realm of magic, dreams, and the unknown.

Naturally I knew nothing of this drink that had been outlawed since 1915, and, which it was believed, drove one mad. My research in the libraries revealed to me the history of the Green Fairy that was simultaneously lauded and cursed, which culminated in the writing of my first book, *Absinthe: Histoire de la Fée Verte* (Berger-Levrault 1983).

One day in August 1991, I received a letter from Columbia Pictures. Francis Ford Coppola was asking me to lend him the very pretty spoon La Feuille d'Absinthe (the Absinthe Leaf), which is one of the more rare and beautiful of absinthe spoons. It was with this very spoon that the Green Fairy had sent a signal to me that it was time to speak of her again. I learned that my book had become almost legendary, and a copy was even to be found in the UCLA library. Thus in September 1991, La Feuille d'Absinthe left for Los Angeles to play its own role in the film *Bram Stoker's Dracula*. That same day, I realized something had changed. The forbidden absinthe once again crossed the seas to America as it had done before in that now-distant era when it was enjoyed everywhere, especially in New Orleans. The still-outlawed Franco-Swiss absinthe was on its way to

Marie-Claude Delahaye outside the Absinthe Museum, Auvers-sur-Oise

A fine display of the Absinthe Museum's art collection

becoming the superstar that it once had been.

Eight years later, my personal confirmation that absinthe had indeed been restored to worldwide popularity occurred in 1999 when I received an e-mail from Arizona, "My name is Betina Wittels. I am a collector of absinthiana, [the technical word for absinthe collectibles] and I am looking for a copy of your first book. You and your reputation are known even here."

I, and other European collectors, could scarcely imagine that on the other side of the ocean lived absinthe enthusiasts looking for the vestiges of the Green Fairy. The quest for the fabled is common to all cultures, and the Green Fairy was beginning to spread her veil over four continents.

From every trip, Betina brings back something treasured—spoons, glasses, everyday objects—that carries the history of the era, which can today be considered as authentic relics of the absinthe epoch. I corresponded with Betina by e-mail until the day she came to Auvers-sur-Oise to visit the Absinthe Museum, which I had created with my own collection. I was walking on air in anticipation when I went to meet her at her hotel to bring her to the museum and was soon caught up in the enthusiasm and energy that caused her to travel thousands of miles to get here, the same enthusiasm that transcends to all who admire the Green Fairy… perhaps even to you.

—Marie-Claude Delahaye
Collector, historian, founder of the
Absinthe Museum, Auvers-sur-Oise

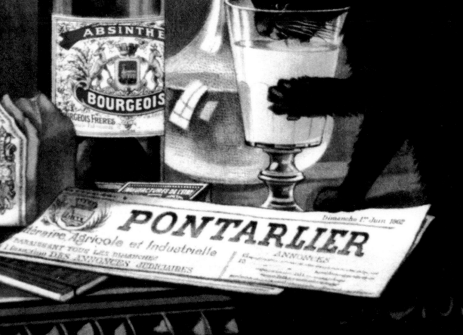

# INTRODUCTION

## BETINA J. WITTELS

*Our lives are never entirely our own. Detours of destiny are everywhere ...*
Although it seems like a century has passed since that fateful evening, I distinctly recall the misty, naked November chill wrapping itself around me like a dark velvet cloak on the eve of my first encounter with absinthe, also known as the *Green Fairy* or *Green Goddess.*

I can still envision that ominously narrow, dimly lit path into Barrio Chino, Barcelona, where I sat squinting through the foggy car window, thinking to myself, "Will the driver force me to get out of the car and walk down the rain-sodden cobblestone streets alone?"

Only moments before, I had stepped into a taxi and whispered the address request in Spanish ... the driver drove away silently. As we approached the narrow calle, where hookers and thieves lurked in the drizzly shadows, he turned hesitantly to me and politely voiced a refusal to cross over the major street of Las Ramblas and into the lamp-lit alley.

While I understood and perhaps even agreed with his better judgment, I knew this would be my last chance. Tomorrow I would depart for my return to America. Meanwhile, simmering in my thoughts was the discovery I made only a

(Opposite) *Absinthe Bourgeois*, 1902

The famous Barrio Chino Calle, Barcelona

Philip Lasala absinthe

few days before when, as my eyes swept through an obscure travel book, my soul lingered upon a single passage that described an elusive, mysterious green elixir; a potion banned almost worldwide, yet occasionally tippled in the Barcelona underworld, poured into odd-shaped glasses and diluted with water that trickled through sugar lumps resting on slotted spoons. It would only be here that I might procure this apparently magical liquor, in a particularly perilous section of town. This peculiar vision clenched my imagination with a relentless grip.

There I was peering through that taxi window, faced with a vexing prospect of having to go the final distance alone. If I stepped outside the taxi, I would become drenched while navigating my way through the shadows. It was midnight, the tumultuous time when the bars of Cataluña are reverberating with decadence. After all, nobody in Barcelona slumbers until after 4:00 a.m., following a strong dose of Saturday night revelry. Despite being cautioned, I was determined to go on, not knowing if I would find another rare opportunity to taste that drink that haunts the pages of history books. I begged the driver to creep forward, threatening to step out and walk the remaining three blocks myself. The driver demanded that I must lock my passenger door if he was going to continue. Admittedly, for a moment, my resolve stumbled. Turning back, however, is not in my nature. So I did as he asked and locked the door. I was quietly thankful, as I reminded myself that at least he had not pushed me out the door.

His instincts of machismo eventually prevailed and, after mustering a bit of courage, we slowly pushed forward. He parked directly in front of a huge, dark wooden door. No other cars were in sight. "Is it even open?" I murmured to myself. The entryway at the corner of Sant Pau #65 did not look like any bar I could recall or would even want to remember. We both stepped out and peered through the wooden slats. The shutters were tightly closed, but slight reverberations of rock music rattled the windows. The taxi driver reluctantly escorted me into Bar Marsella, though he was obviously tempted to abandon me in favor of guarding his taxi from the possible fury of wheel thieves.

On a dusty bar stool in a room with pink walls, beneath a dangling chandelier

riddled with missing bulbs, I partook of my first sip. Absenta Lasala, my first glass of absinthe. I remember it well, sipping the elixir amidst an ambience of uncertainty. The lights flickered; the spoon clinked against the glass. The bar was not what I expected, although looking back I cannot recall just what I expected.

My life has never been the same since that moment. Enchanted, I fell under the spell, not knowing that absinthe would become for me an abode of passion. Having stepped through the entrancing absinthe door, I happened into a mystical world of herbs, forests, bistro cafés, elegantly etched glasses, shimmering topettes, embossed fountains, and intricately shaped sipping accoutrements of which, prior to that first primeval night, I knew nothing. I was equally oblivious to the history, art, literature, poetry, antiques, and passion that spring from absinthe.

The history and art that surrounds the drink has been explored by a scant handful of authors, most concentrating exclusively on its rich history and, to a lesser extent, its depictions in art and the century-old antiques associated with absinthe's preparation. This particular book is intended to be more of a practical guide, written for both present imbibers and those curious souls who are wondering just what absinthe is and if its reputation is as mysteriously powerful as the elixir is warranted.

Robert Hermesch, T. A. Breaux, and I believe that the quest for absinthe knowledge does not culminate in a dead end, but continues as an upwardly winding path in which fairies, poetry, and vision inspire the spirit, quench the body, and soothe the soul. Absinthe is truly a fairy tale with real beginnings and no end.

—Betina J. Wittels

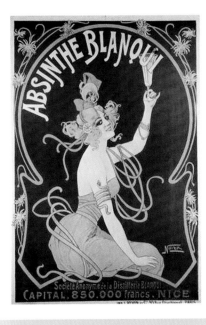

**ABSINTHE BLANQUI, 1895**
Blanqui's red hair is flying as she raises the absinthe glass high above her head as if in a toast. Her eyes are lined with black kohl, the dark intensity meant to capture the ways of the orient. She is surrounded by midnight blue, the color of evening pleasures. Both exotic and subtle, dominating influences of power are present as she wears a golden serpent arm bangle on one arm and a chained bracelet on the other. Yet ribbons are flying every which way from her dress into the breeze. She is free.

L'ABSINTHE

CHAPTER 1

# *The Rise and Fall ...*
# *and Resurrection*

**EMERGENCE**

D r. Pierre Ordinaire, a French expatriate living in Switzerland, invented absinthe near the end of the eighteenth century. His intention was to formulate a digestive tonic that contained wormwood and other regional medicinal herbs. By the end of the eighteenth century, the medicinal properties of wormwood had long been known, but its intensely bitter taste made ingestion most unpleasant. Dr. Ordinaire solved his dilemma with the relatively new science of spirituous distillation. Through his educated efforts, Dr. Ordinaire was able to create a proprietary digestive as tasty as it was efficacious. He shared the liquid alchemy with patients and guests who praised the benefits of his green wonder tonic.

The good doctor's secrets eventually found their way into the hands of Major Dubied. In 1805, Major Dubied, his son Marcelin, and Henri-Louis Pernod, his son-in-law, constructed a small absinthe distillery. In the early years, absinthe

(Opposite) *Orlèans*, a French bar advertisement with cherubs intoxicated by absinthe

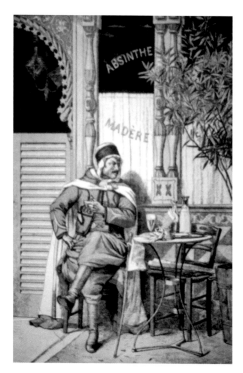

*Á l'Esplanade des Invalides*, 1898
A man from the North African colonies is drinking a glass of absinthe on the Invalide Plaza in Paris
(an illustration from a *Paris Noel* publication)

was just another regionally crafted liquor from the sleepy countryside near the Franco-Swiss border. Early in the nineteenth century, absinthe distribution and notoriety were very limited, but that would change rapidly and dramatically.

## THE PEOPLES' RESTORATIVE

The nineteenth century ushered Europe into the Industrial Age. Change became the order of the day. France's economic, political, and social structures gradually changed, as did Paris. Rail travel made Paris accessible to the rural poor, seeking jobs in service and industry. Bourgeoisie no longer referred to a class of prospering trades people. Paris' population swelled with a new underclass of working poor. Crushing physical labor, low wages, and long hours left little time or money for recreation. Absinthe was relatively affordable and believed to have curative powers, so it was as much a logical choice for workers as for the privileged class.

## I'LL ALWAYS HAVE MY 'RIFLE'

Young Frenchmen entering military life found their lot no easier than that of laborers. The Algerian Campaign presented new challenges to the French Army. The North African extremes of climate, terrain, primitive living conditions, and disease took a toll. Army doctors prescribed official rations of absinthe to be issued to soldiers for the prevention of fevers and treatment of dysentery. Army surgeons believed the liquor could even be used to disinfect drinking water. The medicinal qualities of absinthe may have been uppermost in the surgeons' minds, but abuse grew alarmingly. *L'Eclipse* published a scathing cartoon by André Gill in its June 1874 edition showing an army officer seated before a preposterously large glass of absinthe.

During the campaign, French officers and servicemen brought their favorite drink to Algeria's cafés and nightclubs, where it quickly became fashionable. As seasoned soldiers returned home, they brought with them the anise-flavored

herbal tonic that had befriended them in the desert. Traveling from Marseilles to Paris and beyond, absinthe continued to gain favor. By the mid-nineteenth century, the Pernod Fils distillery was churning out some 20,000 liters a day from twenty-six alambics.

## TOAST OF THE TOWN

Absinthe drinking became an integral part of the irreverent, chaotic lifestyle of bohemian Paris. The Green Fairy emerged as the darling of Paris' café society. France's most prominent writers and artists lauded the virtues of absinthe, among them Paul Verlaine, Arthur Rimbaud, Edgar Degas, Vincent van Gogh, Paul Gauguin, and their contemporaries. So popular was the pastime of drinking absinthe, the traditional cocktail hour in Paris became known as *l'heure verte* (the green hour). Each café had a distinct character and a life all its own. Each provided a backdrop for the exchange of information and ideas, as well as friendships.

Gentlemen toast with Junod Absinthe

## INTERNATIONAL CELEBRITY

Absinthe consumption had all but supplanted wine and brandy consumption in France. By 1908, the many new absinthe distilleries in France (and abroad) began shipping their product to all corners of the globe.

In London, absinthe became the primary drink of the upper crust, intellectuals, and artists. Like Spain, Britain never outlawed the consumption of absinthe.

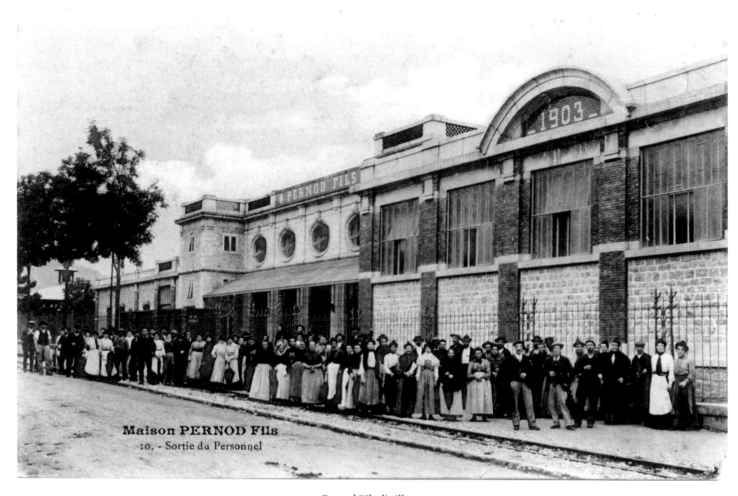

Pernod Fils distillery

From London, the popularity of the drink stretched across to America, spanning from New York to San Francisco. But absinthe received perhaps its most enthusiastic American welcome in the "Little Paris of America," New Orleans.

New Orleans and absinthe seemed to be made for each other—both sinfully delectable and equally enamored by some, as abhorred by others. At the heart of the sipping scene lay the Old Absinthe House Bar, located at the corner of Bourbon and Bienville Streets in the steaming French Quarter. The Old Absinthe House attracted a wide, colorful array of famous imbibers and admirers, including Walt Whitman and Mark Twain, as well as the self-proclaimed wickedest man in the world, Aleister Crowley.

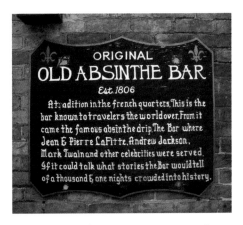

The Old Absinthe House Bar in New Orleans

## A PROLIFERATION OF IMPOSTERS

During absinthe's heyday, the Pernod Fils marque emerged as a national icon and became so closely associated with the green liquor that to ask for absinthe, one simply asked for *un Pernod*.

The tremendous success and notoriety of the Pernod Fils marque did not go unnoticed; imitators proliferated, seeking to profit from the rapid rise in popularity of this once obscure drink. These interlopers unwittingly played a significant role in ruining the reputation of absinthe, often resorting to the inclusion of harmful chemicals in attempts to mimic the appearance of the fine Pernod Fils product. Some went so far as to give their inferior products names that sounded like the spoken word "Pernod" in their attempts to deceive consumers.

No one was more acutely aware of these travesties than the House of Pernod Fils. Pernod Fils fought legal battles against the imitators and published literature denouncing inferior absinthes as detrimental to the entire industry. History would prove the concerns of Pernod Fils to be justified. By 1880, rather than asking for *un Pernod*, a Parisian could order absinthe by the term, *une correspondance*, meaning "a ticket" in English. The term referred to a ticket to Charenton, a well-known insane asylum on the outskirts of the city.

Unscrupulous imitators were known to concoct 'absinthes' that contained poi-

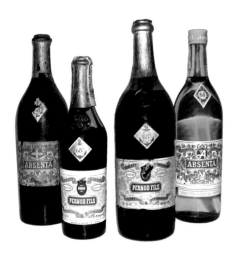

Vintage bottles of Pernod Fils and
Absenta absinthe

This poster dramatically depicting the 1910 absinthe prohibition in Switzerland

sonous colorants to artificially create the desired shade of green for their inferior products. Commonly used harmful adulterants included copper salts, aniline dye, turmeric, and antimony trichloride was occasionally used to improve the louching effect.

Due to a lack of food and beverage quality regulations, these cheap, toxic absinthes were common fare among those of lower socioeconomic status in urban areas. Nevertheless, despite the warnings, the French only increased their absinthe drinking.

## MEDICAL AND SOCIAL OBSERVATIONS

Adding its voice to the growing controversy, the medical establishment began studying the mental and physical effects attributed to chronic absinthe abuse. A grim connection was made between mental and physical degradation. Alcoholism began to be treated as a mental illness, as an increasing number of patients admitted to hospitals confessed to chronic absinthe consumption. The most common treatment was hydrotherapy—patients were confined in hydrotherapy baths for five hours each day. In addition, attendants periodically doused patients' heads with water. Those who were considered 'cured' of their alcoholism were discharged with instructions to restrict their drinking to wine, in the mistaken belief that it would not harm them.

The notable Dr. Valentin Jacques Joseph Magnan and his colleagues saw alcoholism and drug abuse as an emerging pandemic, and with good reason. In 1860, the United States opened opium trade with China. Likewise, coca and its derivative, cocaine, became readily available. Celebrities and socialites indulged in such treats as ether-soaked strawberries. Gradually, it became acceptable to use opiates in social situations, much as one might take an after dinner cigar or drink. Soon, absinthe was paired along with opiates. Maurice Barrymore, the forbearer of the Hollywood family of actors, aptly referred to absinthe as "the paregoric of second childhood."

Dr. Magnan became obsessed with the effects and genetics of absinthe abuse.

His work was extensive, and he conducted research studies specifically involving both the liquor and the essences of wormwood it contained. In spite of his fame, the doctor's conclusions were based on erroneous assumptions and crude research. None of his studies involved human subjects, and Dr. Magnan's published studies did not address the social ramifications of absinthe use.

But that's not to say that others weren't making social observations. In 1860, Henri Balesta was an up-and-coming journalist (and occasional playwright). Balesta's book, *Absinthe et Absintheurs,* was published that year. He was a keen social observer, tracing the lives of heavy absinthe users. Balesta's book broke ground by focusing on the effects of absinthe abuse on the addicts, their families, and the community—observations that would eventually make front-page news and make absinthe abuse all too real.

## CRY MURDER!

Two heinous murders in Switzerland hammered in the first of many coffin nails for the Green Fairy. The first of two horrific events occurred one night in late August

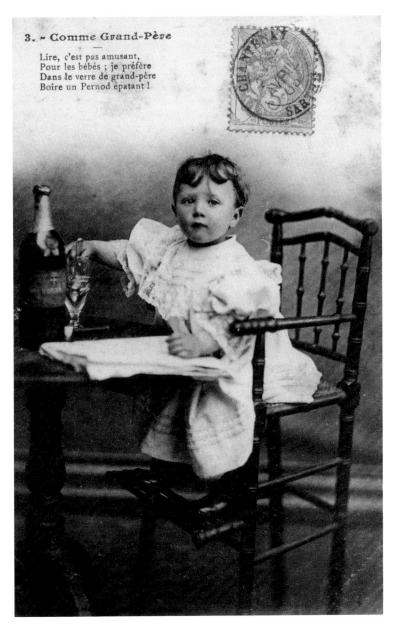

One postcard in a series of six depicting babies with absinthe

A Swiss post-ban liquer d´anise label

1905, in the French-speaking canton of Vaud, Switzerland. A farm laborer, Jean Lanfray, had worked the day in the fields. His drinking schedule began at dawn and included several liters of wine, multiple shots of brandy, and, of course, two glasses of absinthe.

After returning home, he entered into a heated argument with his wife, shooting her in the forehead with his rifle. She was pregnant with a baby boy. In his murderous rage he then shot and killed his two daughters, Rose and Blanche. Immediately afterwards, Lanfray made a clumsy attempt to shoot himself, inflicting a gunshot wound to the jaw that was not life threatening. He was quickly arrested and confined to a hospital. News of the murder spread like wildfire.

The second murder occurred within a few days in Geneva. A known absinthe drinker, suffering the aftereffects of a drinking binge, murdered his wife with a hatchet and revolver.

Soon, an outraged citizenry (including women, who did not yet have the right to vote in Switzerland) responded by petitioning to ban absinthe with a constitutional amendment. Powerful absinthe producers lobbied for liberty within commerce and industry. But the landslide could not be stopped; absinthe production and consumption were banned from Switzerland on October 7, 1910.

## FOR EVERY ACTION, A REACTION

The Swiss ban paved the way for other governments to find justification in following suit. In the mid 1800s, an infestation of Phylloxera invaded the vineyards of France. The proliferation of tiny, aphid-like insect devastated the French wine industry. During this depression of wine stocks, the relatively inexpensive and abundant absinthe displaced wine and brandy as the peoples' choice of tipple. Ultimately, American hybrid grapes provided French vintners with relief, but the fledgling recovery was stifled by the popularity of absinthe.

Suddenly, absinthe had become far more than a competitor; it had become a serious threat. The struggling wine and brandy makers therefore had a substantial interest staked in the demise of absinthe, which became unofficially recog-

nized in France as the national drink. The wine industry persisted for decades in the political exploitation of the thujone controversy (the element found in absinthe said to cause insanity), and sought to blame absinthe for a plethora of societal evils.

Allied with the infamous Temperance League, the unlikely partners spawned bad press and rumors concerning absinthe's toxicity. The public began to believe the allegations that absinthe's habitual use resulted in eventual madness and ruin. This tireless campaign slowly gained momentum over a period of several decades, spreading word of the immoral and degenerative effects of absinthe. Gradually, the wine industry and Temperance League succeeded in demonizing absinthe in the public consciousness, which culminated in the French ban of 1915.

## GOING...GOING...GONE

Within fifteen years, absinthe was banned throughout much of the Western World. In the United States, the law banishing the Green Fairy was passed in 1912, preceding prohibition of all alcoholic beverages by several years.

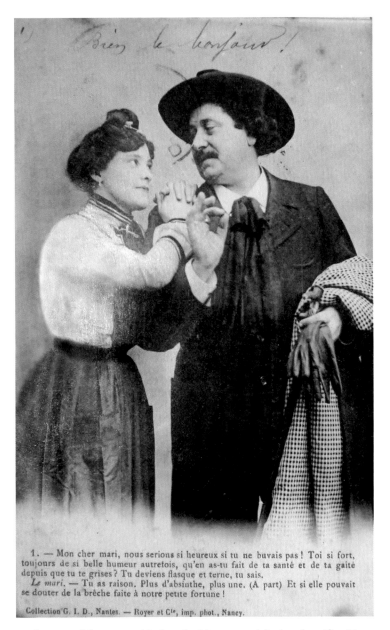

1. — Mon cher mari, nous serions si heureux si tu ne buvais pas ! Toi si fort, toujours de si belle humeur autrefois, qu'en as-tu fait de ta santé et de ta gaîté depuis que tu te grises ? Tu deviens flasque et terne, tu sais.
    Le mari. — Tu as raison. Plus d'absinthe, plus une. (A part) Et si elle pouvait se douter de la brèche faite à notre petite fortune !

Collection G. I. D., Nantes. — Royer et Cᵢᵉ, imp. phot., Nancy.

This turn of the century black-and-white postcard depicts the wife asking her husband why he's so tired and ill, since he was always in good health. He says that she's right and he promises not to drink absinthe anymore. The look between the two does not appear to contain any serious scolding.

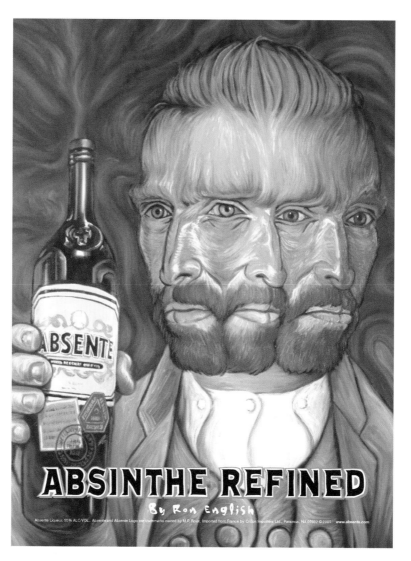

Absinthe Refined is a contemporary version of the wormwood-free drink. It is legal in the countries that ban certain compounds found in true absinthe.

In the years following the ban of absinthe from the European countries that popularized it, imitation absinthes (containing no wormwood) gradually appeared on the market. These absinthe substitutes appeared in the form of herbal wines, aperitifs, liqueurs d'anis, and, eventually, pastis. The descendents of many such post-ban products linger to the present day. Following the demographic devastation of the Great War, producers of these liquors attempted to revive the popularity of the age-old absinthe ritual, but the experience was just not the same. The Green Fairy had fled, but not forever.

## VANQUISHED, BUT NOT FORGOTTEN

From 1915 until 1993, some seventy-eight years in all, absinthe was virtually eliminated throughout the world. But the Green Fairy has since re-appeared, now glittering throughout the four corners of the globe.

In 2001, an absinthe bar opened in Sao Paulo, Brazil. Currently, 28,000 bottles of absinthe per month are imbibed in that country. Two restaurants, Lumiere and Pastis are serving a legalized Czech version of the elixir in Vancouver, Canada. Germany and Australia have now opened their respective country's doors to the Green Fairy, and an absinthe bar opened in the Philippines in 2003, as well as another in Santiago, Chile.

Doorknobs are turning and words are no longer whispered as people share communication over a swirling glass, chilled water, a slotted spoon, a sugar cube, and the luminescent nearness of the Green Fairy. After nearly a century of exile, extraction, denial, and exclusion, absinthe is now in the full throes of worldwide revival.

*The Temptation*, this postcard seductively suggests Oxygénée Absinthe

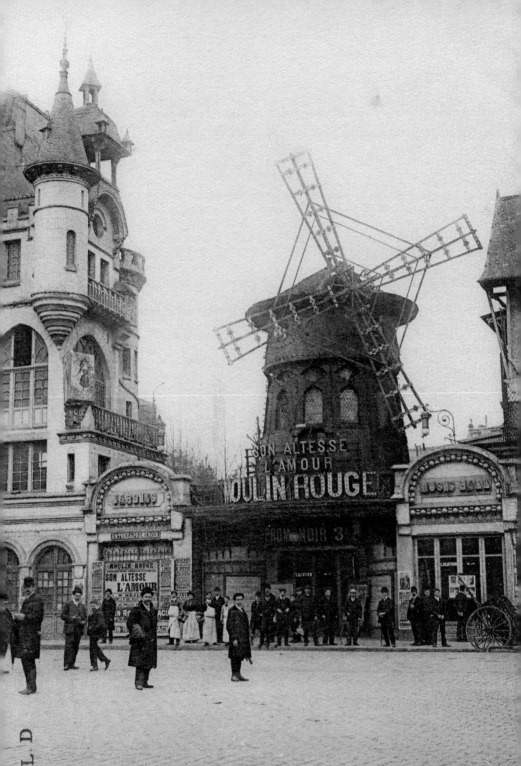

PARIS. — Le Moulin Rouge.

# CHAPTER 2

# *The Visionaries' Muse*

## WHAT MADNESS IS THIS?

*A*bsinthe's famous imbibers are as varied and intriguing as the drink itself. Fueled by its uniquely stimulating qualities, some of the more notorious wrote, painted, and professed with the Green Fairy at their side. Whether the effects of absinthe on their creativity, clarity, mental acuity, and expression were real or imagined, the visionaries' achievements are legendary. *Absintheur, absintheuse, absinthiste, absinthism*—all describe the twin phenomena of the drink's popularity and misuse.

## THE POETS
*Charles Baudelaire*
Charles Baudelaire, one of France's premier poets, was known for making disparaging remarks about Paris. He quipped publicly that Paris had become "a center, radiating universal stupidity." Nonetheless Paris served as his teacher and provided an inexhaustible source of subject matter for his poetry, including the

(Opposite) The celebrated Parisian pleasure dome, Moulin Rouge

Caricature of Charles Baudelaire by Nadar

art, artists, and absinthe that so inspired Baudelaire. Paris would also teach the writer of excess, through fashion and drink.

Misunderstood by the public and critics, Baudelaire's *Les Paradis Artificiels* condemned fake mysticism. The book was published late in his career, and the poet had come to see alcohol and drugs as providers of a contrived, instant paradise. Baudelaire's premise was that modern man sought the most rapid (and false) path to spiritual gratification.

In his own time, the author was criticized for praising all that was decadent. However, after the publication of *Les Paradis Artificiels,* Baudelaire became vehemently opposed to the use of alcohol and drugs, citing the extreme dangers of addiction. Sadly, the author recognized his own peril too late. After years of exile in Belgium, Baudelaire died at the age of forty-six, ravaged by venereal disease and long-term substance addictions.

### Arthur Rimbaud & Paul Verlaine

Arthur Rimbaud, a great admirer of Charles Baudelaire, came to Paris in 1871. Although very young, he was a poet of formidable talent. Rimbaud developed a rather skewed interpretation of Baudelaire's work, believing Baudelaire had freed himself through drugs to attain the height of creativity; Rimbaud freed himself from social convention seeking his own poetic expression, but not without help.

Rimbaud's life became intertwined with the life of another great poetic talent, Paul Verlaine. Verlaine was twenty-seven-years old when he met the struggling Rimbaud, who was only sixteen-years old at the time. Verlaine proclaimed the youngster a poetic genius, introducing his protégée to his circle of Parnassian poets and their favorite drink.

By his mid-twenties, Verlaine had already lived a life touched by tragedy and bouts of violence. In spite of his drinking and temper, Verlaine was married to a woman close in age to Rimbaud. To the detriment of his marriage, Verlaine became more than a mentor to Rimbaud, the two became lovers. The more he

saw of Rimbaud, the more Verlaine drank. The more he drank, the more viciously he abused his wife.

The tumultuous relationship between the two poets was punctuated by absinthe binges, accompanied by episodes of debauchery and violence. Verlaine's bohemian associates found Rimbaud's behavior outrageous. Although they challenged social convention, they had moral standards and a code of behavior. Rimbaud became increasingly deluded, viewing himself as the quintessential poet, a God-like visionary.

Predictably, the two poets began to wear on one another, or rather, Rimbaud began to find his older companion tedious. They left Paris for London, but were doomed to split. The end may have been predictable, but it was ugly, even for these two. Verlaine fled London for Brussels, where he threatened to kill himself. Rimbaud traveled to Brussels to plead with Verlaine not to harm himself. The conversation grew acrimonious, and Verlaine shot Rimbaud. The wound was superficial, and the shooter was filled with remorse. No one contacted the police.

A nineteenth century portrait of Paul Verlaine, showing the Green Fairy's influence on his body

"Long live *L'Académie d'Absomphe* ... It is the most delicate and trembling of all vestments, this drunkenness by virtue of the sagebrush of the glaciers, absomphe."
*Arthur Rimbaud*, poet

Verlaine's sense of guilt was short lived. As his ex-lover attempted to leave the city, Verlaine shot at him a second time. When the police arrived, they inquired about the shooting *and* the relationship between the two men. Verlaine admitted to the police he had engaged in homosexual acts with the young poet. He served a sentence of five years in prison for sodomy. Upon his release from prison, Verlaine's wife and friends shunned him. He resumed his life as best he could, declaring he would never again touch absinthe.

But by the 1890s, holding forth in Latin Quarter cafés, his health and reputation were in tatters. He taught for a time, taking a student, Lucien Létinois, under his wing. Apparently, the young man reminded him of Rimbaud. Verlaine seduced the youngster and they lived as lovers for several years. By the time of Létinois' untimely death, Verlaine had become an object of pity and occasional ridicule.

In the end, Verlaine paid dearly for his lifestyle. He suffered numerous illnesses and hospitalizations before his death, still drinking absinthe smuggled into the hospital room by a few well-wishing friends.

Rimbaud had many years ahead of him when Verlaine went to prison, but they would not be years of writing. Soon after the episodes in Brussels, Rimbaud abandoned poetry. Following the publication of *A Season in Hell*, he began a new life as a soldier of fortune. He joined the Dutch Army and deserted not long afterward. He traveled from Java to North Africa, becoming a trader. Some of the commodities he traded included guns and slaves.

When Rimbaud was thirty-six-years old, a mysterious lesion developed on one of his legs. It was resistant to treatment and became a painful abscess. He returned home for surgery, but died from complications just short of his thirty-seventh birthday. No literary figures attended the funeral, and Verlaine was conspicuously absent.

The 1995 film *Total Eclipse* examines the relationship between Paul Verlaine and Arthur Rimbaud. Unfortunately, it is *all* that the film examines. Producing this film was an ambitious undertaking for Jean-Pierre Ramsay Levi, in terms of capturing the imagination of film audiences. These are dead poets ... dead *French* poets. Other than academicians, not many people read Verlaine's work, and the resurgence of interest in Rimbaud's poetry hasn't exactly shaken the earth for most moviegoers.

In the film, as in life, the love affair and the creative lives of the two are subrogated to their notorious behavior. Leonardo DiCaprio's portrayal of Arthur Rimbaud gives audiences the right contrast between the mercurial Rimbaud and the conflicted Verlaine, but reveals little more than Rimbaud's sadistic streak, and David Thewlis portrays Verlaine as a mere weakling.

The affair between Verlaine and Rimbaud, perhaps enhanced by absinthe, begins in rollicking pleasure. In life, Paul Verlaine was so fond of absinthe he incorporated it into his personal greeting. In one famous anecdote, Verlaine shouts to a passerby on a train, "I take it with sugar!"

Sadly, overindulgence became as much a problem for Verlaine as did obsession. Once Verlaine's and Rimbaud's pleasure turns to a sort of frenetic overindulgence, the chemistry between the two turns to pure vitriol. Unfortunately, once the two split, the film fails to keep their lives relevant.

Although the screenplay contains compelling elements, it would be difficult for audiences of the 1990s to invest sympathy in either of the poets. As the public's attitude toward absinthe changed at the beginning of the twentieth century, the end of the century brought change in attitudes toward sexual exploitation, as well as emotional and physical battery. In fact, as on film, the artistic lives of Verlaine and Rimbaud spiraled downward as their personal lives unraveled. Perhaps the Green Fairy opened Verlaine to more than he could handle. He was still enraptured with his green muse, as he died. She, at least, had not disappointed.

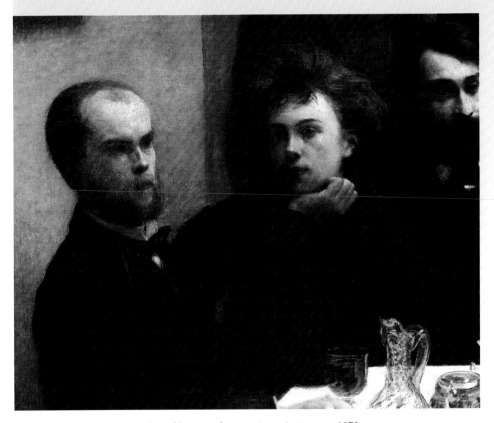

*The Table Corner* by Henri Fantin-Latour, 1872
This detail shows Paul Verlaine, Arthur Rimbaud, and Elzéar Bonnier

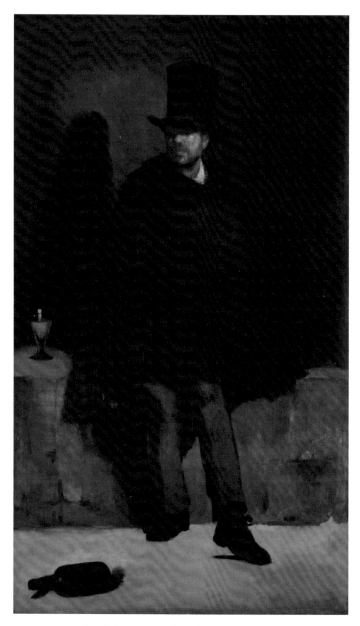

*The Absinthe Drinker* by Edouard Manet, 1858

## THE PAINTERS

### *Edouard Manet*

From his studio in the Rue Lavoisier, Edouard Manet ventured into the famous Tortoni's Café, drinking absinthe with Gustave Courbet, Charles Baudelaire, and other members of the avant guard. Like Baudelaire, Manet became known for his extravagant dress and the two became fast friends. More than a kindred spirit, Baudelaire would become a mentor and the subject of some of the painter's work.

Manet painted what he saw in contemporary life. Despite the excellence of his work, Manet's portrait, *The Absinthe Drinker,* was excluded from the prestigious Salon of Paris in 1859. The Salon was the definitive show for Paris' crème de la crème of artists, intellectuals, and socialites. Baudelaire, who was present when news of the rejection came, believed there was nothing the artist could do other than remain true to his vision.

Manet had, indeed, painted what he saw and became pivotal in the emergence of modern painting. The image depicted a seedy, unkempt man standing stridently beside his last glass of absinthe, the spent bottle at his feet. Strikingly rendered, it was a stark portrayal of a local drunkard named Collardet. Paris' establishment was not yet prepared to unveil quite such a truthful image of the city's underbelly. Even fellow artists were taken aback by Manet's lack of sentimentality and social value.

### *Edgar Degas*

As fondly noted, the cafés of Paris provided the milieu for a great exchange of intellectual and artistic ideas. Perhaps the most famous of these gathering places was the Nouvelle-Athènes, where Edouard Manet socialized with Edgar Degas and other prominent artists.

In 1876, the Nouvelle-Athènes became the backdrop for Degas' *L'Absinthe.* Like Manet, Degas used actual subjects for his portrayal of absinthe drinkers. The subjects were actress Ellen Andrée and the engraver Marcellin Desboutin, both acquaintances of the artist. The image is of a pair of absinthe drinkers,

## DISTINGUISHED WOMEN

Building a chronicle of celebrated women in the arts who were fond of absinthe is nearly impossible. Even during the height of absinthe's popularity, images of "respectable" women enjoying the beverage appeared in the form of poster art. The models were mostly celebrated for their beauty. No wonder actress Sara Bernhardt sued when her image appeared on an absinthe poster advertisement.

As Parisian women began to enjoy absinthe and other aperitifs in significant numbers, so did scathing social criticism of absinthists. Meanwhile, Victorian attitudes toward women and drink spread beyond the British Empire—London's reaction, not to Degas' painting *L'Absinthe*, but to its female subject, actress Ellen Andrée was public vilification. Interestingly, fashionable Englishwomen could, however, inject themselves with morphine or consume ether-soaked strawberries at dinner parties without fear of being ostracized.

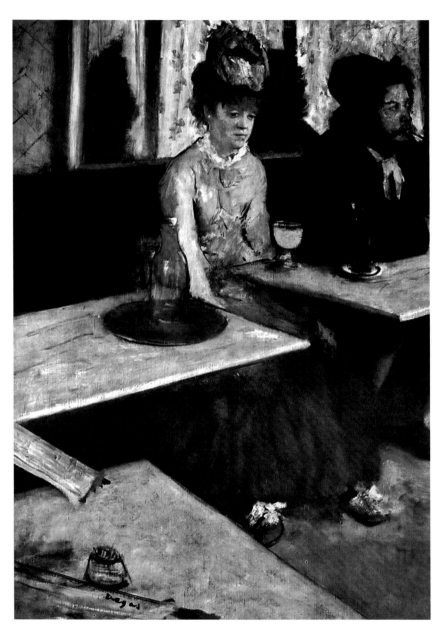

*L'Absinthe* by Edgar Degas, 1876

seated in a café during *l'heure verte*. The worn and pale subjects are portrayed without romantic illusion, appearing in separate reverie.

Some observers commented that *L'Absinthe* had none of the edge of Manet's portrayal of Collardet. But in London, the painting received equal amounts of disdain. Perhaps because of its subject matter, the painting drew bitter remarks from prominent London critics, including the characterization of his female subject as a whore. The controversy grew ugly, fueled by Francophobia and the fear that absinthism would grow to taint the national character. Nonetheless, the painting was sold to a British collector and survives today as a classic.

## *Vincent van Gogh*

Vincent van Gogh was one of the most famous and controversial of the absinthe drinkers. However, the extent of his habit is unknown. The affair with the Green Fairy began during his time in Paris, where he drank and associated with fellow impressionists such as Claude Monet, Paul Gauguin, Camille Pissarro, Jean-François Raffaëlli, Paul Signac, Edgar Degas, Pierre-Auguste Renoir, and Henri de Toulouse-Lautrec.

Fellow artists Toulouse-Lautrec and Gauguin introduced van Gogh to absinthe and French prostitutes. Ironically, out of concern for his friend, Toulouse-Lautrec then urged the mercurial van Gogh to move to Arles. Joining him, Gauguin moved to Arles shortly afterward, sharing a house with him. Only weeks had passed when a dazed van Gogh confronted Gauguin with razor in hand. Gauguin managed to stare him down and escaped harm. Later in the evening, van Gogh used the razor to cut off a piece of his own ear.

Some claim that van Gogh was an addict who came to rely on absinthe for creative energy. Others contend that he seldom drank absinthe, and, in fact, discouraged its abuse among those around him. Many have attributed the artist's emotional problems to the drink, however, it is apparent to most scholars the man was suffering from chronic depression as early as his adolescence. While absinthe likely did not ameliorate the depression, most agree it was not entirely

> "I sit at my door, smoking a cigarette and sipping my absinthe, and I enjoy every day without a care in the world."
> *Paul Gauguin*, artist

> "...the zouaves, the brothels, the adorable little Arlesiennes going to First Communion, the priest in his surplice, looking like a dangerous rhinoceros, the people that drink absinthe, all seem to me creatures from another world."
> *Vincent van Gogh*, artist

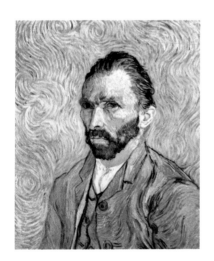

*Self Portrait* by Vincent Van Gogh, 1889

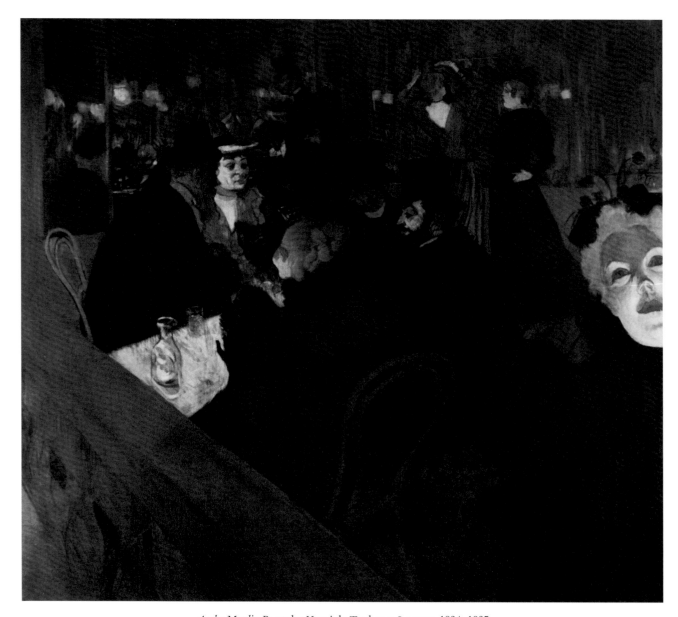

*At the Moulin Rouge* by Henri de Toulouse-Lautrec, 1894–1895

to blame for van Gogh's dark moods. Furthermore, he was syphilitic, and could have been in the final stages of the disease when he committed suicide.

Scientists have also theorized that van Gogh may have developed an aberrant craving for terpenes. The craving could certainly explain his desire to consume absinth, which contains terpenes. This has recently been suggested as an explanation of why the artist drank turpentine and ingested paint.

And what of his bright, yellow sunflowers and the midnight blue *Starry Night*? His revolutionary use of color and form could have been affected by the lingering influence of the fairy muse. However, a recent research study indicates van Gogh's use of color, specifically his proclivity for yellows, was most likely a reflection of personal preference. He was certainly influenced by the impasto paintings of his contemporary, Adolphe Monticelli.

## Henri de Toulouse-Lautrec

Alphonse de Toulouse Lautrec was a direct descendant of the Counts of Toulouse. The eccentric Count married his first cousin, Countess Adele Tapie de Celeyran, who gave birth to Henri de Toulouse-Lautrec. Never healthy, Toulouse-Lautrec suffered a congenital bone condition. In his early teens, he broke both legs in separate incidents. The bone tissue did not heal properly and the boy stopped growing at four feet, eleven inches. As the Count distanced himself from his only child, the Countess became overly solicitous, and art became her son's escape and his promise.

It was acceptable for Toulouse-Lautrec to become an accomplished painter, a tradition among the men of his family. For him to become a working artist, however, would be unthinkable. Still, his father sent him to study with French masters. Toulouse-Lautrec was a serious student, who went on to study in prestigious ateliers. Soon he abandoned classical painting—he preferred the work of the Impressionists.

In 1887, Toulouse-Lautrec inhaled life in Paris. It was the end of the century, and the city was the epicenter of *change*. Plans were underway for Paris

We know that the Belle Époque was not all beautiful. It *did* have its seamy side. Opening in October 1899, the Moulin Rouge was an extravagant experiment, designed to dazzle anyone and invite everyone. In addition to a seedy underclass, Paris burgeoned with a bourgeois class and the industrial workers to support it. From nobles to pickpockets, pleasure seekers flocked to the "Palace of Women."

Artist Adolphe Willette orchestrated the exotic theme and richly colored décor of the Moulin Rouge. Parisians turned out en masse to celebrate the opening of the pleasure dome, and it did not disappoint. In addition to the stage performers, there were stand-up comics, roving performers, and carnival freaks. Most famous among the diversions was the risqué can-can.

All under one roof, one could find a main stage with an orchestra pit above; a dance floor; courtesans and in-house prostitutes; sexual voyeur opportunities; galleries; a garden café, complete with monkeys in costume; a huge, stuffed carcass of an elephant in the garden areas, which also housed a nightclub with an Arabian theme complete with belly dancers; and an opium den. And throughout the entire scene, the Green Fairy played her pivotal role.

As for Hollywood's take on this sin palace, *Moulin Rogue*, starring Nicole Kidman and Ewan McGregor, presented more of a visual extravaganza, lacking a bit in the heart, or rather underbelly, of the historic spot. However, the visual explosion of the movie did capture the look and appeal of anachronism. The Green Fairy sequence (with Kylie Minogue as the star) and an absinthe-drinking, serenading Henri de Toulouse-Lautrec (played by John Leguizamo) kindled more than a cult interest in the green muse. Although the film does not pretend to re-create or rewrite history, audiences experience the collision of a romantic ideal with stark reality.

to host the World's Fair; the Eiffel Tower was in the design stage. The World's Fair would spark an interest in Eastern cultures, and 'Japonisme' became the rage. Toulouse-Lautrec became an ardent admirer and collector of Japanese woodblock prints. A fascination with the work of Ukio-e master, Utamaro, and with printmaking heavily influenced Toulouse-Lautrec's work.

In a radical departure from even the avant-garde, Toulouse-Lautrec sold his work on the street. His work sometimes appeared on the walls of the cafés and restaurants of Montmartre, places he frequented. He exhibited in galleries, but, as his reputation grew, commissions for his work kept him working feverishly.

Toulouse-Lautrec's denizens of the night were the residents of and visitors to Montmartre. He lived in Montmartre, embracing the bohemian lifestyle. He frequented the dance halls, brothels, and bars; his legacy is a detailed chronicle of place and time. During his life in Montmartre, the artist produced 351 lithographs and nine drypoints. He would create sketches at night, working during the day to turn the drawings into paintings or to work with printers to produce lithographs. Many of his celebrity subjects were also friends. He counted among his acquaintances, Jane Avril, Yvette Guilbert, May Belfort, and Aristide Bruant.

Montmartre was a place of excess, and Toulouse-Lautrec developed a taste for it all, primary among them, prostitutes and liquor. His favorite drink was absinthe, which he sometimes drank with cognac, a drink called an "Earthquake." He carried a hollow walking stick, filled with absinthe, and his motto was, "Drink little, but drink often." Sadly, by his mid-thirties, Toulouse-Lautrec was drinking more than he was working—absinthe louched with water, absinthe with white or red wine, absinthe in artfully layered cocktails called "Rainbow Cups."

Word of his drinking and ill health (he was also plagued with syphilis) reached his parents at their country estate. Friends and a relative reported seeing him drunk. Late in February of 1899, Toulouse-Lautrec's doctor and a relative of the Countess convinced the distraught parents to take action. After drinking himself into a near stupor one March night, Toulouse-Lautrec awoke the next morning in an asylum. He had been kidnapped and was kept in the asylum by force.

Henri was terrified of being kept prisoner. He begged his father for his release, but to no avail. He remained there until May. Upon release, Toulouse-Lautrec returned to his work, and avoided alcohol for a time. But in 1902, Henri de Toulouse-Lautrec died, wrapped in his mother's arms.

## Pablo Picasso

Pablo Picasso's early acquaintance with absinthe was instructive, to say the least. Like many of his contemporaries, Picasso used absinthe in a specific social context. In his youth, Picasso admired Alfred Jarry, emulating both Jarry's style and the playwright's enjoyment of absinthe. However, when Picasso's generation was coming into its own, the Green Fairy, reputation in tatters, was doomed. The evils of absinthism pervaded even Picasso's beloved puppet theatres.

By 1900, Picasso and his close associate, Spanish artist Carlos Casagemas, had moved from Barcelona to Paris. A year later, Picasso's work had attracted attention, although he had failed to achieve commercial success. Casagemas appeared

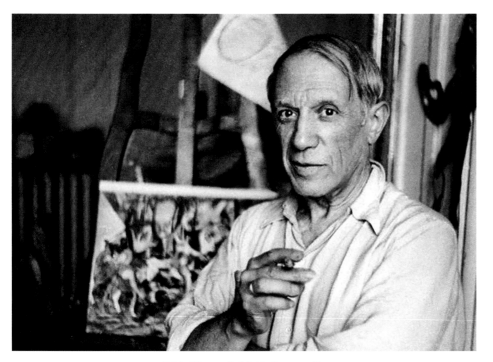

Pablo Picasso in his Paris art studio

to be as pleased to be part of the Montmartre arts scene as Picasso, however, he committed suicide in February 1901.

Picasso's sadness, perhaps combined with a sense of futility, changed his art. He began to paint in blues and greens; the subjects of his paintings changed, as well. He painted clowns, street performers, beggars, and prostitutes—sad, pallid people, living on the edge. The emotional content of Picasso's painting is clear in *The Absinthe Drinker* and *Woman Drinking Absinthe.* Although, Picasso, himself, enjoyed absinthe without apparent harmful effects, these are unflinching portraits of addiction. We see in these paintings the beginnings of change in the artist's use of form. More change was imminent.

Between 1902 and 1903, Picasso painted a watercolor of absinthe drinkers, his style took a distinct turn toward cubism. *The Poet Cornutti* is sometimes referred to as *Absinthe*. Picasso's close associates and the kindest of his critics could not comprehend the development in Picasso's style. In 1911, when Picasso painted *The Glass of Absinthe,* he was at the height of his development as a cubist. Whether or not absinthe influenced Picasso to break one artistic convention after another, it inspired masterpieces of painting and a wonderful, whimsical bronze. Pablo Picasso continued to explore his artistic expression over a long, tremendously productive, career.

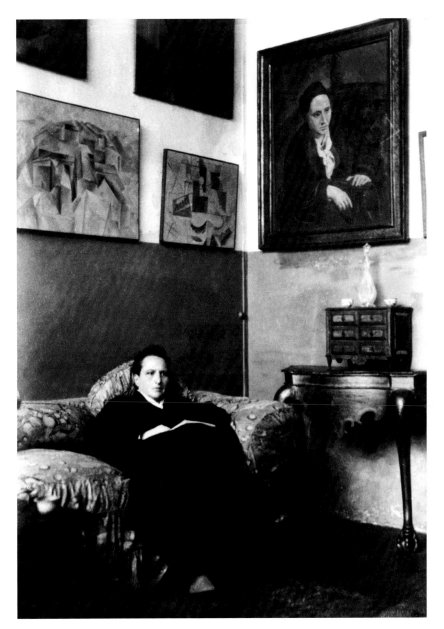

Picasso's social circle included one of the greatest art enthusiasts, Gertrude Stein. Here she sits in her famed Left Bank apartment with her 1906 portrait, painted by Picasso, dominating the wall. Paintings by Georges Braque are also displayed.

### THE LOST GENERATION'S DEN MOTHER

Although not much has been written about famous women who consumed absinthe, it seems *likely* Gertrude Stein served it to her guests. Based on the lingering popularity of absinthe in Paris, Stein and her lover, Alice B. Toklas, would probably have imbibed. But absinthe's role in Gertrude Stein's creative life is purely speculative.

The consummate hostess, Gertrude Stein entertained the great artists and writers of her time. She and her brother Leo lived together at 27 Rue de Fleurus. The art collection in their home included paintings by the great impressionists, Renoir, Gauguin, and Cezanne. She also befriended Pablo Picasso, and collected pieces of his work, and even agreed to sit for him in 1906.

The Den Mother of the Lost Generation, Stein became famous in her own right with her book, *The Autobiography of Alice B. Toklas*, in addition to such publications as, *Tender Buttons: Objects, Food, Rooms* and *Three Lives*, among other great contributions. As she became well known, her criticism could make or break an aspiring writer. Fortunately, for Ernest Hemingway, she considered him talented, albeit flawed. She contributed creative direction to his early fiction writing, as did Ezra Pound.

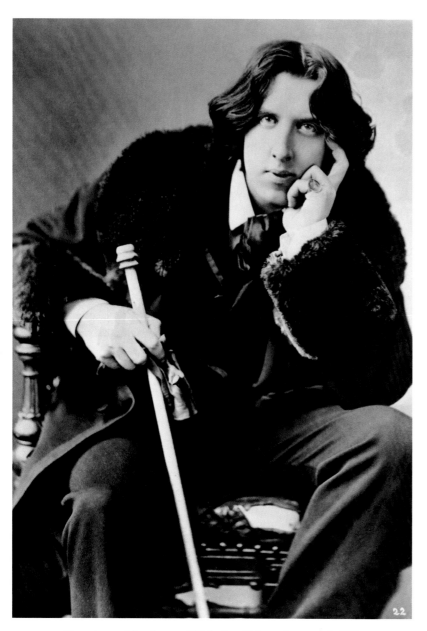

The witty and flamboyant Wilde sits still for a photograph, 1882

## THE PLAYWRIGHTS

### *Oscar Wilde*

As Paul Verlaine's life and career had reached low ebb, he met Oscar Wilde in a Parisian café. Like Verlaine, the young Irish playwright had a taste for absinthe. The Trinity College and Oxford educated Wilde would come to share more in common with Verlaine than either man could imagine.

Wilde was the son of a prominent surgeon and an accomplished writer. Wilde's mother adored her son, and he was an exceptionally intelligent child. His career at Magdalen College, Oxford, was brilliant. Before leaving Oxford, Wilde had already received a prestigious award for English verse. Physically imposing and colorful in his appearance, Wilde became known as the founder of the Aesthetic Movement. He believed in the ability of the artist to portray an ideal, beautiful, version of nature. The philosophy of art for art's sake was espoused by many of Wilde's contemporaries and caught the imagination of Victorian society. But Wilde stood out as more than an aesthete; he was an accomplished writer of both poetry and prose. His hallmark was his agile wit.

It was Oscar Wilde who quipped, "Absinthe makes the tart grow fonder." In a more serious vein, he shared insights about the effects of absinthe with John Fothergill. Fothergill included them in a book entitled, *My Three Inns*. Wilde described the stages of absinthe drinking: "The first stage is like ordinary drinking, the second when you begin to see monstrous and cruel things, but if you can persevere, you will enter in upon the third stage where you see things that you *want* to see, wonderful, curious things." Of one evening at the Café Royal, Wilde intimated his absinthe-drinking experience:

> "… I had just got into the third stage when a waiter came in with a green apron and began to pile the chairs on the tables, 'Time to go sir,' he called to me. Then he brought in a watering can and began to water the floor, 'Time's up, sir. I'm afraid you must go now, sir.'
>
> 'What are your favorite flowers, waiter? … I'm sure that tulips are your favorite flowers,' I said, and as I got up and passed out into the street I felt the heavy tulip heads brushing against my shins."

For a decade spanning from 1885 to 1895, Wilde appeared to have absolutely everything. He was married with children, and had written children's books and a first novel, *A Picture of Dorian Gray*. He had also written a number of plays, such as *Lady Windermere's Fan*, *A Woman of No Importance*, and *An Ideal Husband*. During the London theatre season of 1885, Wilde had two hits running concurrently, *An Ideal Husband* and *The Importance of Being Earnest*. But reminiscent of Paul Verlaine, Wilde became infatuated with another man, the wrong man. His attraction to Lord Alfred Douglas enraged none other than the Marquis of Queensbury, who was Lord Douglas' father. The clash ended unhappily for Wilde, who sued the Marquis for libel. The court case ended in a judgment against Wilde, who was sentenced to two years of hard labor.

"The first month of marriage is the honeymoon, and the second is the absinthe-moon."
*Voltaire*, author, philosopher, satirist

"A glass of absinthe is as poetical as anything in the world. What difference is there between a glass of absinthe and a sunset?"
*Oscar Wilde*, playwright, author

Wilde protested the cruelties he suffered in the British prison system, and published one of his final works, *The Ballad of Reading Gaol*. But Wilde never recovered his health, career, or finances. He assumed the name Sebastian Melmoth and proclaimed himself a vagabond. In 1900, Wilde lived in Paris' seedy Latin Quarter. He developed a mastoid infection (possibly a complication of syphilis) and died of meningitis. He was survived by his two children, and had become a Roman Catholic convert before his death at the age of forty-six.

## Alfred Jarry

In 1888, Alfred Jarry was a schoolboy with comic wit and was constantly entertained by a physics teacher who invited satire. A young Jarry and two schoolmates collaborated to write a drama featuring the antics of their instructor, Monsieur Herbert. The three boys had unwittingly set Jarry on the path to becoming the father of the Theatre of the Absurd.

Jarry's adult life echoed his drinking predecessors of the art world. He was particularly fond of absinthe and once painted himself green in tribute to the Green Fairy. Strangely enough, Jarry had a low regard for water, which he refused to use in the potent drink. Like Arthur Rimbaud, Jarry viewed drinking (at least, *his* drinking) as the means to an end, freeing the pure artist within. Apparently, his attempts at detachment did not stop with undiluted absinthe or other liquors; he also came to use ether as a frequent intoxicant.

Reminiscent of Rimbaud, Jarry's star rose very early, gaining him entrée into intellectual circles while he was still in his teens and, like Baudelaire, regarded Parisian society with disgust. Jarry's mannerisms, both in speech and in dress, earned him a reputation as an eccentric. Fond of bicycling, he frequently wore racing attire. He was also the proud owner of a paper shirt with a painted bowtie, and once wore a pair of borrowed ladies' high-heeled shoes to a funeral.

If the object of a theatrical work is to stir the audience, Jarry's dramatic debut in December of 1896 could be counted an enormous success. The audience went wild, but the reaction ranged from bewilderment to outrage. The play, *Ubu Roi*,

"Jarry is an absinthe-surrealist."

*André Breton*, author

evokes the same mixed reactions in modern audiences. The protagonist, Père Ubu, is a caricature of Macbeth. He is the embodiment of ambition run amok, grossness, and greed. Two sequels, *Ubu Cuckolded* and *Ubu* would follow *Ubu Roi*, but would not be performed during the author's life. Jarry's only novel contemplated the fusion of night and day through hallucination. His proudest accomplishment, however, was his invention of Pataphysics, defined as the science of imaginary solutions, which symbolically attributes the properties of objects, described by their virtuality, to their lineaments.

By 1906, Jarry's absinthe drinking had reached critical proportions. His sister attempted to intervene by sheltering him in her country home, but the writer returned to his Paris apartment. He died there of tubercular meningitis at the age thirty-four.

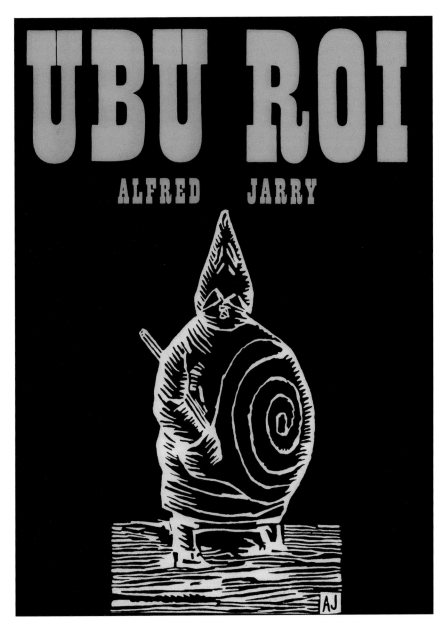

Cover art for Jarry's published version of *Ubu Roi*

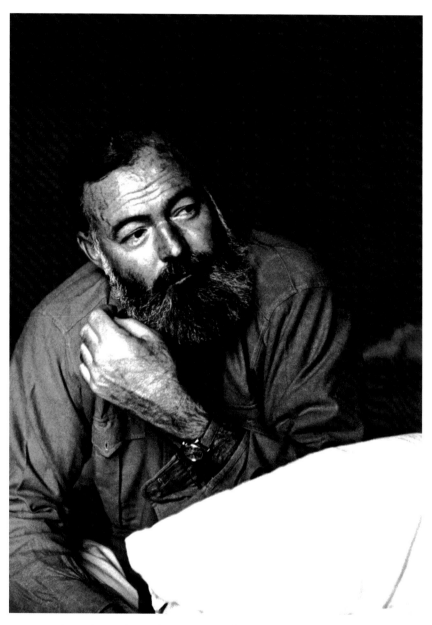

Legendary writer and war correspondent, Ernest Hemingway, 1944

## THE AUTHORS

### Ernest Hemingway

Photographed sipping absinthe with friends in Spain, it is thought that Ernest Hemingway likely developed a lasting taste for the green elixir in Paris. His acquaintance with Gertrude Stein and invitations to her celebrated Salon introduced the young writer to Left Bank artists and writers of the 1920s, such as Ezra Pound and Pablo Picasso. These celebrated parties may have provided an entrée to the world of absinthe.

Regardless of how Hemingway first became acquainted with the Green Fairy, he became an ardent fan and even had his own signature cocktail that combined absinthe with champagne. In an ironic vein, Hemingway named this cocktail, "Death in the Afternoon."

Hemingway's writing career is legendary. From a cub reporter with little fiction writing under his belt, Ernest Hemingway was awarded the 1954 Nobel Prize in Literature. Beginning in 1923, with *Three Stories and Ten Poems*, the author's star began to rise. His collection of

vignettes, *In Our Time,* appeared in France. With the addition of fourteen short stories, the book was published in the U.S. in 1925. In 1926, New York publisher Charles Scribner published *The Torrents of Spring* and *The Sun Also Rises.* The latter defined what Hemingway termed the 'Lost Generation.' His collection of short stories, *Men Without Women,* followed. In 1929, the year his father committed suicide, Hemingway published *A Farewell to Arms,* the classic novel of the World War I.

The author's 1940 novel, *For Whom the Bell Tolls,* which describes absinthe's invocation of memories, drew from his experiences in the Spanish Civil War. His African travels and misadventures resulted in *The Green Hills of Africa* and *The Snows of Mount Kilimanjaro.* And the years of living and deep-sea fishing in Cuba were brought to life in *The Old Man and the Sea,* which earned him the 1953 Pulitzer Prize in Fiction.

For his distinguished lifetime writing career, Ernest Hemingway received the Nobel Prize in Literature. His tragic suicide came only eleven years later, in July 1961. The author was said to have suffered bouts of heavy drinking and depression bordering on despair. But, it seems unlikely absinthe was the prime contributor, so much as life experience. One of Hemingway's favorite French expressions, one he used liberally, was, *Il faut d'abord durer.* The man was durable, but his work endures.

## Edward Alexander (Aleister) Crowley

Edward Alexander Crowley was born in 1875 to wealthy, religious Victorians. He renamed himself Aleister, partly in defiance and partly in denial; his father's name was Edward Alexander. He rapidly grew from a rebellious child to a promiscuous teen, and by seventeen had contracted gonorrhea.

After his academic career at Cambridge University, punctuated with on-going sexual adventures with both sexes, Crowley began a career in Britain's Diplomatic Service, but soon abandoned the notion of becoming a diplomat. He wanted to make a more lasting mark on the world, which in time he would.

"From the Marquesas I sailed with sufficient absinthe in ballast to last me to Tahiti."

*Jack London,* author

The Victorian fascination with the occult influenced Crowley to join The Hermetic Order of the Golden Dawn. He was in good company. The leader of the order was Samuel Liddell MacGregor Mathers. Among the London members were William Butler Yeats, Maud Gonne, Constance Wilde, Arthur Machen, Moina Bergson, Arthur Edward Waite, Florence Farr, Algernon Blackwood, as well as (reputedly) Sax Rhomer, and Bram Stoker.

The Golden Dawn formed a system of belief around the Kabbalah, alchemy, tarot, astrology, divination, numerology, and ritual magic. At the base of their belief were elements of Free Masonry and the Rosicrucian Brotherhood. Crowley's membership in the Order was troubled; not only was Crowley divisive, he was a known homosexual. Expelled after a turbulent two years, Crowley moved on.

He traveled extensively and met and married a self-proclaimed clairvoyant, Rose Kelly. After the wedding, the couple headed toward Egypt, where Crowley experienced a spiritual breakthrough. He had sought for some years to contact his "Holy Guardian Angel." With the help of his wife, Crowley invoked the Egyptian God Horus. Through Horus, Crowley contacted an entity he believed to be his angel. Aiwass "dictated" a book to Crowley over a period of days. The text, *The Book of the Law*, synthesized Crowley's personal belief.

With typical bravado, Crowley proclaimed the end of the Aeon of Osiris and the beginning of the Aeon of Horus. Of course, Crowley was the prophet of the new era, and old religions were passé. He also used the momentum to proclaim himself the reigning magician of the world. He would eventually form the Argenteum Astrum (Order of the Silver Star), basing much of the organization's belief on *The Book of the Law*. The ruling principle of Crowley's philosophy is generally misunderstood. It is, simply, "Do what thou wilt shall be the whole of the law." Crowley's interpretation of free will involved answering to one's higher consciousness. Interestingly, Crowley, himself, struggled with this very concept.

The struggle for supremacy as a Magus ended for a time. In 1905, he joined a climbing expedition to the Himalayas. Several members of the team died

"I am for wine and against absinthe, as I am for tradition and against revolution."
*Léon Daudet*, rightwing extremist

during the unfortunate expedition. Possibly suffering post-traumatic stress, Crowley traveled alone in China for years…without contacting Rose or their little daughter. The child died in Rangoon, India, while Crowley was absent. Crowley, who eventually succumbed to drug addiction, divorced Rose for her alcoholism. After the divorce, and after more sojourns into the world of magic, Crowley became a member of OTO, the Order of the Templars of the East, and headed up the English-speaking branch of OTO. He would ultimately become the head of the OTO world organization.

During World War I, Crowley lived in the United States, finding his way to New Orleans and the Old Absinthe House. Crowley's love of absinthe took him to the Old Absinthe House regularly, where Crowley designated himself the "Wickedest Man in the World"—he later came to regret the image he chose. Inspired by his first experience with absinthe, Crowley wrote an essay entitled, *Absinthe: The Green Goddess.* He wrote:

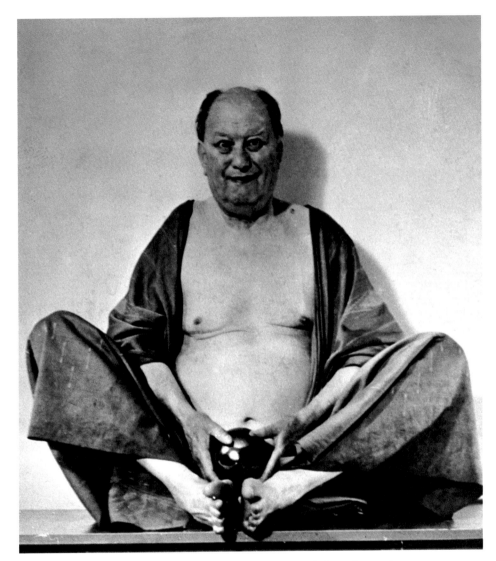

Aleister Crowley posing as Fo Hi, the Chinese God of Laughter and Money

Aleister Crowley and Samuel Liddel MacGregor Mathers had become archrivals. Fighting for supremacy as the world's most powerful Magus, Crowley made some extravagant claims. He said Mathers sent a vampire to do battle with him. She appeared to him as a "young woman of bewitching beauty." In spite of his promiscuous tendencies, Crowley did not fall prey to her guiles; he changed her back, he said, to a decaying crone of sixty.

Evidently, this was not the end of the clash. Crowley's bloodhounds died and, apparently, some servants in his household succumbed to illness. His response? Naturally, not to be bested, he sent the demon Beelzebub and forty-nine fiends to visit his wrath on Mathers. He died of natural causes years later, but believers attribute the death to Crowley.

"What is there in absinthe that makes it a separate cult? The effects of its abuse are totally distinct from those of other stimulants. Even in ruin and in degradation it remains a thing apart: its victims wear a ghastly aureole all their own, and in their peculiar hell yet gloat with a sinister perversion of pride that they are not as other men."

At the end of the war, Crowley married Leah Hirsig, the "Scarlet Woman." In 1920, the couple moved to Sicily. Crowley established the Abbey of Thelema in that country. With Leah he had another daughter, Poupee. The Abbey was not what it appeared to be. It was a squalid place in which his daughter and one of his protégées died. Betty May, the wife of the protégée Raoul Loveday, sold her story of the scandalous Abbey in a London tabloid.

In time, Crowley became addicted to heroin and cocaine. He wrote *Diary of a Drug Fiend* about a couple battling addiction. His time was running out. Benito Mussolini's government expelled Crowley from Sicily in 1923. Although Crowley's *Majick: In Theory and In Practice* appeared in print in 1929, the expulsion from Sicily marked the beginning of the end. He was unable to settle anywhere or find anyone to publish his writing, and he remained a heroin addict. Crowley died in 1947, at the age of seventy-two.

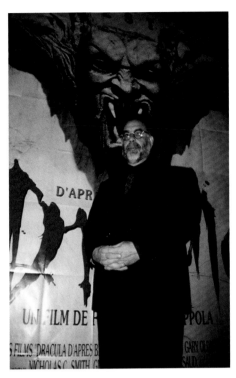

Francis Ford Coppola at the paris film premiere of *Bram Stoker's Dracula*

Francis Ford Coppola's film *Bram Stoker's Dracula* takes film audiences on a journey from fifteenth century Transylvania to Victorian England and back to the Carpathian Mountains of Transylvania. Stoker's Dracula remains *the* definitive Dracula story, among many fictitious and scholarly works. His vampire Count is elegantly attired in evening dress; his copious black cape and fine, white fangs hint at his ability to morph into an enormous bat. It is a story of the quintessential predator, the personification of evil. In Stoker's book, the ancient Count changes only his age; he becomes younger as he feeds on the blood of his victims.

It was Hollywood that brought the sexual overtones of the Dracula story to life. The unforgettable Bella Lugosi portrayed Dracula in the 1931 film as a seductive figure. In the 1979 film version, Frank Langella further romanticized the Dracula role. The Coppola film brings a weird mixture of eternal love and sexual predation to the screen.

Gary Oldman's Count Dracula is condemned to eternal life without his beautiful, young wife. In the Victorian setting of the film, the youthful incarnation of the vampire discovers his eternal love in Mina Murray, played by Winona Ryder. Mina is the naïve, pretty wife of a young realtor, played by Keanu Reeves.

Dracula sips absinthe with Mina in a café. As she sucks on a sugar cube, Dracula subtly seduces her. Absinthe's aphrodisiac qualities were hardly lost on the filmmakers, as displayed when Dracula says to her, "Absinthe is the aphrodisiac of the self. The Green Fairy who lives in the absinthe wants your soul. But you are safe with me." Mina cannot escape the aftermath of that moment of seduction. She is hopelessly under the spell of the vampire.

Hollywood's adaptation of Stoker's book would have been too sexually explicit for publication in Bram Stoker's time. The film's Dracula is based, in part, on the life of a historical figure, Vlad Tepes (Vlad the Impaler), a descendant of the original Vlad Dracul. The name Dracul, or Dragon, has a double meaning: it means dragon, but it also refers to the devil.

Vlad Dracul was a knight of the Order of the Dragon, an order founded in 1410 for the protection of the Holy Roman Empire and the Catholic Church. Coppola's Dracula, Prince Vlad III, was his son. Vlad III, came to be known as Vlad Tepes, because of his favorite means of punishing enemies and criminals. During the course of his reign, Vlad the Impaler executed tens of thousands of people, possibly as many as 100,000. He impaled men, women, and children on stakes, sometimes while feasting with members of his court. When Vlad died in battle, he was buried in the Monastery of Snagov. When the site was excavated (in 1931), there was no sign of the coffin or the remains.

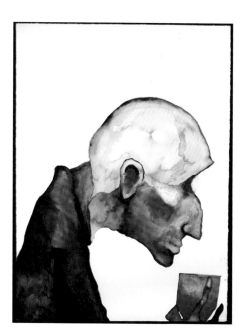

*When I Get Old* by Marilyn Manson

## MODERN ENTERTAINERS

*Marilyn Manson*

Born Brian Walker, January 5, 1971, shock-rocker Marilyn Manson began his career as a music journalist. Manson's first band, Marilyn Manson and the Spooky Kids, set out to push censors to their maximum limits. The band, consisting of Manson, Olivia Newton-Bundy (who was replaced by Gidget Gein), Daisy Berkowitz, Zsa Zsa Speck (later, Madonna Wayne Gacy), and Sara Lee Lucas, recorded *Portrait of an American Family* under Trent Reznor's label, Nothing Records. The record went gold, and Manson's band went on tour with Nine Inch Nails. Manson followed with a double-platinum release, *Smells Like Children*, in 1995.

Had his recordings not been such an enormous success, Manson's sometimes shocking behavior might not have produced ripples of disapproval. As it was, they precipitated a major uproar, particularly among parents of pre-teens and teenagers in the United States. After the 1996 production of another critically acclaimed platinum release, *Antichrist Superstar*, Senator Joseph Lieberman became the spokesperson for outraged Americans. The histrionics did not stop Manson, whose group recorded *Mechanical Animals* in 1998 and *Holy Wood* in 2000.

It is not all that surprising that the Green Fairy has found her way into Manson's world, a drink with a notorious reputation for causing social decay. *The Golden Age of Grotesque* is a two-fold artistic presentation—album and art exhibit. In a June 2003 interview with *Spin* magazine, Manson spoke of the influence absinthe had on this album, "…it's not the first record I've made while drinking absinthe, but this album does embrace the release of imagination that absinthe taps into. Listen to the title track: That song was completely written and recorded in twelve hours, on one bottle of absinthe. That song sounds like absinthe."

A gallery full of Manson's watercolors was displayed also under the name *The Golden Age of Grotesque*. A number of the paintings reflect an absinthe-induced expression. "Harlequin Jack and the Absinthe Bunny" consists of a man and an almost menacing rabbit. Manson offered an interpretation by saying, "When I

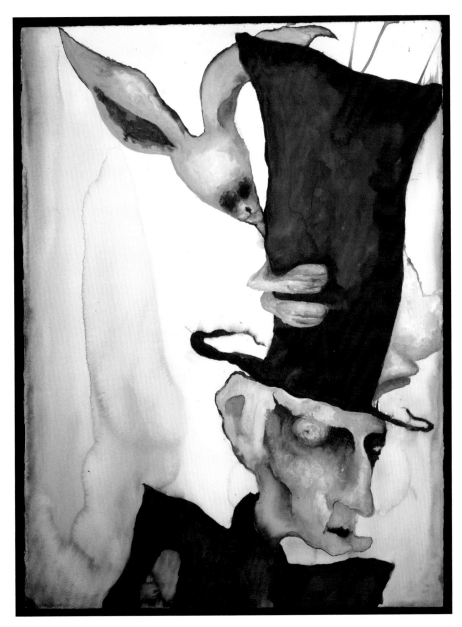

*Harlequin Jack and the Absinthe Bunny* by Marilyn Manson

**DITA VON TEESE**

The ultimate retro pinup girl, Dita Von Teese is old Hollywood glamour at its finest. Hailed as the "only worthy successor to Bettie Page," Dita has become the most visible face and form in fetish. A longtime favorite Playboy special editions model, Dita appeared on the December 2002 Holiday Gala Issue, showcasing her burlesque shows and impeccable vintage style.

As a performer, Dita takes her audience back in time with classic striptease, and her elaborate burlesque acts have made her the preferred headliner for special events all over the world. She is known far and wide for her classic "Martini Glass" routine, but as a tribute to Marilyn Manson's Grotesque Burlesque and his "mOBSCENE" music video in which she appeared, she re-created the routine to feature absinthe as the tempting drink of choice.

Her performance credits range from wild fetish parties to the most elegant black tie galas, such as U.K.'s Rubber Ball and Torture Garden, Exotic Erotic Ball, Teaseorama, L.A. Fetish Ball, Swank, Burlesque Fest, as well as performances for WET Gin by Beefeater, Spike TV, and Playboy special events. Dita was also a featured guest star with the Pussycat Dolls, an L.A. troupe featuring celebrities such as Christina Applegate, Gwen Stefani, Carmen Electra, and Christina Aguilera.

drink sometimes, the rabbit pulls me out of the hat. This was actually stained with absinthe. I was drinking as I was painting and put my brush in the wrong one. It makes a nice stain, so I figured I didn't want to waste it."

"When I Get Old" shows an old, hunched-over man holding a glass of absinthe in his weathered hand. Manson reflected, "The old bald man drinking the glass of absinthe is kind of inspired by William S. Burroughs and how I imagine myself to be when I am old. That's how I'd like to see myself if I live to be that age." It will be interesting to see how long the Green Fairy's muse will stay with Manson, perhaps until old age?

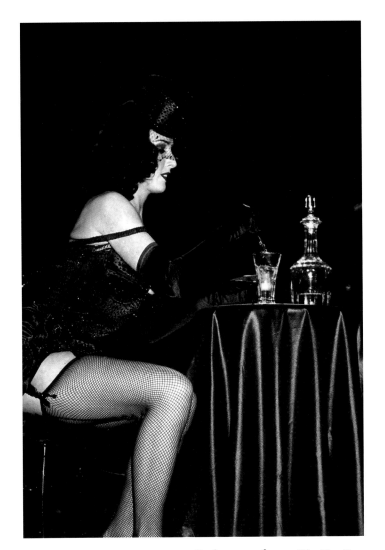

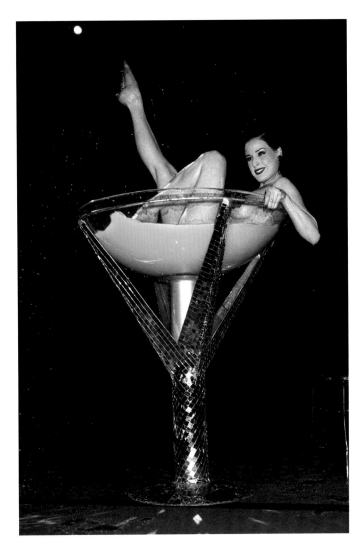

Burlesque performer Dita Von Teese performing her "Absinthe Glass" routine

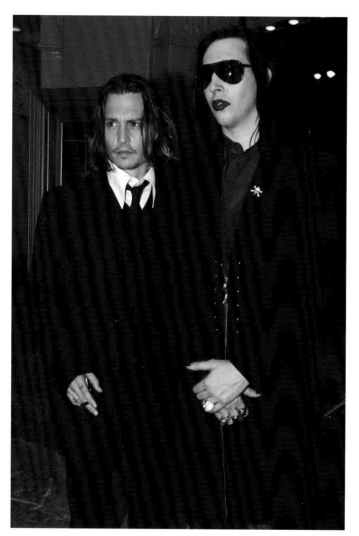

Johnny Depp and Marilyn Manson at a movie premiere for *From Hell*

### Johnny Depp

Johnny Depp, a man of contrasts, was not always an actor. A precocious sixteen-year old, John Christopher Depp II left high school to pursue a musical career. By his early twenties, the unconventional Depp's career had stalled and his marriage was on the skids. Depp's former wife, a makeup artist, introduced him to Nicolas Cage in a Los Angeles club, and they disliked each other instantly.

In spite of a rocky beginning, their friendship developed. It was Cage who recognized Depp's potential for acting and Cage's agent agreed, finding a bit part for Depp in *Nightmare on Elm Street*. The young-looking Depp subsequently accepted a television engagement. His intention in accepting a role with *21 Jump Street* was to temporarily bridge a gap in movie engagements.

But with his television status, it took some effort and luck for Depp to be taken seriously as an actor. His role in the movie *Cry Baby* poked fun at the teen idol image; subsequent roles in *Edward Scissorhands*, *Benny and Joon*, *Ed Wood*, *Sleepy Hollow*, *Fear and Loathing in Las Vegas*, *What's Eating Gilbert Grape*, *The Ninth Gate*, and *Blow* proved Depp to be an astonishing actor with depth and an ability to play unusual characters.

As it goes for most film stars, Depp's private life became fodder for the tabloids. Some highly publicized fiascos contributed to Depp's reputation as a "bad boy" and his lifestyle and romances were too high profile to ignore. His name has been linked with such women as Winona Ryder, Kate Moss, and, of course, Vanessa Paradis. Happily for Depp, his romance with Vanessa Paradis has lasted, he was even credited for playing guitar on her album "Bliss." The couple started

their family with the birth of daughter, Lily-Rose Melody, followed by their son Jack.

In early 1999, Johnny Depp, Sean Penn, and Mick Hucknall opened a restaurant and bar, The Man Ray, on the Rue Marbeuf in Paris. Also in 1999, the French film industry recognized his film career, awarding him an Honorary Cesar Award. Depp's love for France rivals his fondness for absinthe. His role in the film, *From Hell*, is that of a visionary detective, who uses absinthe to enhance his insights into criminals and the crimes they commit. Depp and company selected La Fèe Absinthe as the celebratory drink for the film openings. Depp attended the movie premiere with fellow absinthe drinker, Marilyn Manson. It is rumored that Depp was quoted as saying (at a unrelated event), "…if you drink too much absinthe, you suddenly realize why van Gogh cut his ear off."

Exploring the world and mind of a serial killer is to descend into personal hell. In the film *From Hell*, Johnny Depp plays the role of the police investigator charged with solving the grisly murders and mutilations of five prostitutes in turn of the century London. The crimes were committed in the notorious Whitechapel District of the city, over a ten-week period in 1899. The murderer, who became known as Jack the Ripper, was never brought to justice; the crimes remain unsolved today. At the time the crimes were committed, they inspired sensational press coverage and public hysteria. It was the beginning of tabloid journalism.

In Whitechapel, there was cause for terror. Clearly, the murders were related and carefully planned; the murderer stalked his hapless victims. The quest for Jack the Ripper's identity led all the way to Queen Victoria's inner circle. It is important to note the film is based on the classic graphic novel, written by Alan Moore and illustrated by Eddie Campbell. The author described the *From Hell* series, subtitled, "Being a Melodrama in Sixteen Parts," as the post-mortem of a historical occurrence, using fiction as a scalpel. Although the crimes were gruesome (the women were mutilated with surgical instruments with a surgeon's skill), Moore's interest and his graphic novel were beyond morbid curiosity and sensationalism.

Depp's character, Fred Abberline, had the reputation for being brilliant. We know Abberline was caught in an unhappy marriage and that he drank absinthe and used opiates. He was a kind of visionary, and felt absinthe and opiates provided an entrée into the commission of the crimes. Who better to portray Abberline than Johnny Depp? Depp's acting in this film is both intelligent and insightful. An absinthe connoisseur, he knows the reputation *and* effects of the liquor.

"Absinthe is the paregoric of second childhood." *Maurice Barrymore*, actor

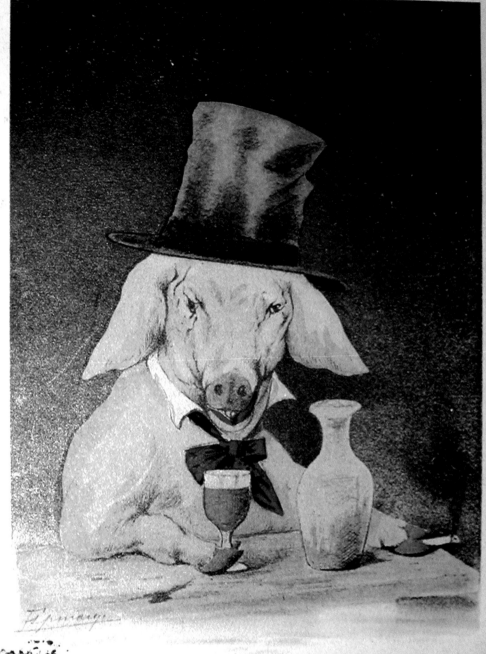

de l'Absinthe

16-4-04

# CHAPTER 3

# *The Sip*

## BENIGN SPIRIT OR MALEFACTOR

Absinthe enjoys a tradition of being touted as more than just an alcoholic beverage. Fanciers compare the objects and ritual associated with the preparation and meditative nature of absinthe to the Japanese tea ceremony. To some, the absinthe ceremony is an institution of the bourgeoisie, to others, a monument to decadence. In any case, absinthe is certainly the most notorious of spirits and is as intriguing as it is misunderstood.

Fans of the drink claim the absinthe experience to be distinctive from that of ordinary liquor. Regardless of the high percentage of alcohol, drinkers claim to remain focused, alert, and vivified. Properly prepared and carefully consumed, absinthe does not simply anesthetize the imbiber in the usual fashion. The unique lucidity (a.k.a., secondary effects) can differ from person to person. A kaleidoscopic experience can result from the dynamics between chemistry, mood, expectation, and tolerance, together with the particular brand and quality of absinthe.

(Opposite) This ad, perhaps intending to be critical, shows a formally attired pig drinking absinthe

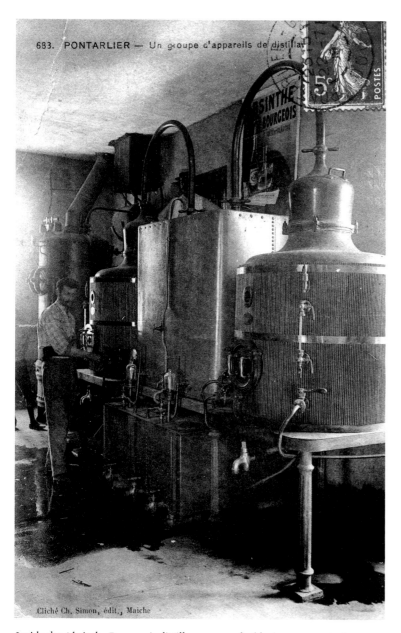

683. PONTARLIER — Un groupe d'appareils de distillat

Cliché Ch. Simon, édit., Maiche

Inside the Absinthe Bourgeois distillery—note the black cat poster in the upper right corner

## THE COMPOSITION OF ABSINTHE

Despite its revival, the origins, character, and contents of absinthe seem to have become obscured with the passage of time. Absinthe is a potent herbal liquor, historically ranging from 55 to 75 percent (up to 150 proof) in alcoholic strength. Its infamous green tint traditionally resulted from the presence of chlorophyll, although the artificially derived colors of modern interpretations tend to vary along a glittery spectrum of green, gold, brown, and even red. Sometimes pale and medicinal, other times emerald and herbal, absinthe's unique appearance contributes to its worldwide mystique.

Equally famous is the peculiar louching effect that occurs when cool water is dripped into the drink (a necessary step, as drinking absinthe neat can result in gratuitous tears and choking due to the intense taste). Upon the addition of water, the transparent green tint slowly transforms into a milky white cloud. This effect occurs as essential oils precipitate, releasing a bouquet of hidden aromas and subtle flavors.

Absinthe is distilled from anise, fennel, hyssop, melissa, juniper, chamomile, and other herbs. The herb selection, propor-

tion, and preparation are important parts of each distiller's secret recipe. But the principal herbal constituent of absinthe is *Artemisia absinthium* (Grand Wormwood), a plant whose purported medicinal properties are as hotly debated as the drink itself. A perennial aromatic shrub, wormwood grows wild along roadsides, fence lines, pastures, and fallow fields. Its appearance is characterized by dark, slender, green leaves covered with soft gray hairs and velvety undersides.

In ancient times, wormwood was valued for its medicinal properties where it was employed as a vermifuge, flea and moth repellent, insecticide, digestive aid, and an aid to ease menstrual cramps. During the Middle Ages, it was believed to protect against plague and other demonic maladies. Today, in addition to absinthe, extracts of wormwood are used as counter-irritants in over-the-counter pharmaceuticals. Regardless of its use throughout the years, wormwood has continually received cautionary documentation. The careless use of the herb can be dangerous, though the levels and effects of wormwood's toxicity to humans have yet to be scientifically evaluated.

## THUJONE, MADNESS OR MYTH?

At the heart of the mystery surrounding absinthe is the compound thujone. It is classified as a monoterpene, which is a class of molecules found in the essences of various plants and flowers. Found in wormwood and a vast array of other plants, herbs, and spices, thujone is a colorless liquid with a heady menthol-like odor.

Thujone has been shown through in vitro laboratory studies that it may affect certain elements of brain chemistry. Scientists once hypothesized that thujone bound itself to the brain's cannabinoid receptors, resulting in sensations similar to those experienced by smoking marijuana. This theory was based on the similarities in molecular structure between thujone and *tetrahydrocanol* (THC, the active component in marijuana). Despite this similarity, a study in 1997 by Meschler, Marsh, and Howlett conclusively debunked this theory, proving that thujone does not bind with cannabinoid receptors.

**FATAL MALADIES**

While wormwood oil is available from a variety of companies specializing in essential oils, this toxic oil is not used in the proper making of absinthe and should never be used in a misguided attempt to do so. Direct ingestion of wormwood oil has been shown to cause epileptic seizures, renal failure, convulsions, and a host of other potentially fatal maladies.

The most recent study, conducted by researchers at University of California, Berkeley and Northwestern University Medical School in Chicago, has shown how thujone may affect the body's neurological system. The human brain produces gamma-amino butyric acid (GABA). GABA's primary function is to inhibit nerve impulses, likened to brakes on a car in heavy traffic. Thujone can block the brain cell receptors that normally pick up GABA. Thus, the "brakes" release, permitting nerve impulses to fire in areas that would otherwise be blocked. Without GABA, our nerve impulses fire too easily; signals become less controlled, exploring previously uncharted perceptual territory. It should be noted, however, that this study was demonstrated only in laboratory experiments and was not a study conducted with absinthe or with actual living subjects.

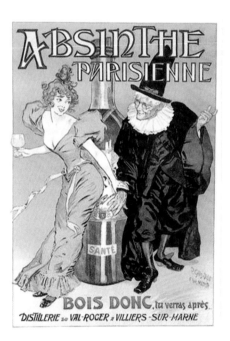

*Absinthe Parisienne* by Lois Maltese, 1894

**ABSINTHE PARISIENNE, 1894**

This is an unusual, perplexing poster. A young woman is touching the hand of an older man who looks like a wizard in his strange costume and hat. Reading the history of the times, the anti-alcohol league, in coalition with medical authorities, was opposing absinthe during that time.

Wearing a reveling garment of blue, the flirtatious woman is the one who is grasping a large glass of absinthe while the gentleman seems to be point to a direction in which he desires that she follow. By her daring dress and provocative smile, one wonders what is the interaction with this man. She seems to be patting his hand in patronizing fashion and beckoning him one way (as her body is turned in movement), as though saying, "If you only had a drink, you would not be criticizing me …"

One of the man's boots is turned in her direction and the other in the opposite direction. He is torn, unsure of where his desires want to go. Her smile is playful, patronizing, and amused rather than taking him seriously. This is the only poster that displays an absinthe bottle the same size as the characters. Between the two figures lies the huge, life-size absinthe bottle. The artist, Lois Maltese, was later known for erotic and sadomasochistic themes in his illustrations.

There have also been explorations into the cumulative effects of thujone on the brain. What are the consequences of habitual use of absinthe? Studies conducted on rats in the 1960s found that a daily diet of ten milligrams per day resulted in 5 percent accumulation. After approximately five weeks, many of the rats began experiencing convulsions. There have also been documented cases of humans who experienced similar reactions after having unwittingly imbibed essences containing thujone for several days. However, in no way does this prove or disprove that prolonged absinthe use will result in such unfavorable medical conditions.

Relevant or not, since the commercial absinthes of today rarely contain more than ten milligrams of thujone (in accordance with European beverage quality laws), absinthes produced and marketed to modern consumers will unlikely develop an ominous reputation of driving drinkers to criminal acts or the madhouse. But regardless of the various findings, continuous use of any drug over long periods of time takes its toll on both the mind and body.

## SAVORING THE FLAVORS OF ABSINTHE

The subtleties in flavor of absinthe traditionally vary to some degree in accordance to the particular region of production. Its primary essence is one of anise, which is similar to anisette and sometimes referred to (incorrectly) as "licorice."

As previously noted, absinthe takes a rough ride down the esophagus if taken straight. When louched with cold water, however, it may treat the palate to a prolonged, multi-level tasting experience. The addition of sugar, although always optional, is often considered a necessity in the absinthe preparation ritual, melding the contrasting textures of alcohol and herbs. The resultant alchemy creates a composite of flavors that far exceeds the sum of its individual components.

## A CAVEAT FOR ABSINTHE DRINKERS

Absinthe should not be taken with psychoactive drugs, antidepressants, or any other substance that is contraindicated for use with alcohol. Do not drink absinthe or any liquor if you have epilepsy or any other neurological disorder.

Here a man can't resist the irresistible charms of absinthe

*L'Absinthe Oxygénée,* 1895

Do not drink absinthe or any liquor if you are an alcoholic.

We do not recommend drinking more than three or four glasses of absinthe in one sitting, as absinthe is usually greater than 90 proof—sip, do not guzzle. The timing of absinthe's euphoria is another unique aspect of its enjoyment and is very important to consider. The initial absence of a drunken fog may mislead one into quaffing more than he or she should in a given period of time. The result of such thinking can be messy, and certainly dangerous, as continuous imbibing packs a delayed wallop. Please, enjoy the elixir with grace, ease, and appreciation.

## METHODS TO THE SO-CALLED MADNESS

Sipping absinthe is a ritual, art, and meditation on the ethereal. The moment is everything, as it is with all genuine things in life.

### *Classic French Absinthe Ritual*

- Pour approximately one shot (½–1 oz.) of absinthe into a tall glass
- Balance your absinthe spoon atop the glass
- If you take sugar, place the lump atop the spoon
- Take about three pours worth of chilled water,  slowly drizzling it over the sugar cube. The absinthe should immediately begin to louche into a white, sage, or pearly-gray color.

Eric Longuet, a French collector, demonstrates the classic French method

*Contemporary Czech Burning Spoon Method\**

- Pour approximately one shot of absinthe into a small tumbler
- Gently dip one teaspoon of sugar into the absinthe so that the sugar stays on the spoon, absorbing the liquor
- Remove the spoon, hold it above the absinthe, and then set fire to the sugar, letting it burn for about a minute until the sugar bubbles and begins to caramelize
- Blow out the flame, then stir the absinthe with the sugared spoon
- Add equal measure of water and ice

The burning method is popular at the Benidorm Bar, Barcelona

## *German Vacuum Inhale Method**

- Pour one shot of absinthe (room temperature) into a glass and then light the absinthe
- After three to four seconds, extinguish the flame by placing a hand over the glass, therefore creating a sealed vacuum
- Inside the glass a change in pressure results, which pulls at the palm of the hand
- Knock the glass three to four times on the table (only sturdy and heavy glasses will withstand this treatment so use a light touch)
- Slide your hand slightly from the top of the glass, leaving a tiny space open
- Quickly inhale the vapors

*Warning: Absinthe is extremely flammable. Please be careful when performing either of these two rituals.

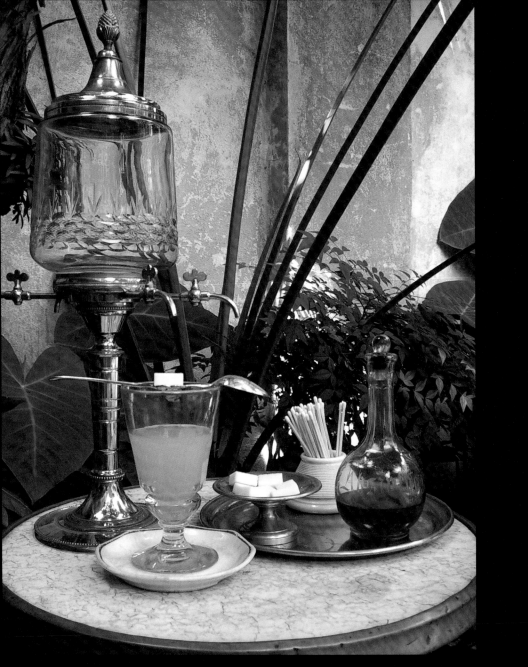

# CHAPTER 4

## *Collectibles*

### ANTIQUE TABLE SETTINGS

*T*he basic tools of the absintheur are essentially a spoon, glass, sugar cube, chilled water, and absinthe. None of the other objects are actually necessary to prepare the drink, but they are important for instigating a type of visual hypnosis and bringing richness to the ceremony.

The old absinthe spoons, paintings, advertisements, and glasses are undeniably gorgeous. The intricacy of detail of a Coquille St. Jacques spoon or the burning gaze of a Jean Beraud painting do not speak of mere oblivion into another alcoholic binge. A rare surge of creative energy peaked during the Belle Epoque era, and whether absinthe spawned this outpouring or merely assisted in catalyzing its evolution, the art objects from that era are seemingly conceived from an outburst of creative color.

(Opposite) A complete antique absinthe table setting.

Le Tour Eiffel spoon

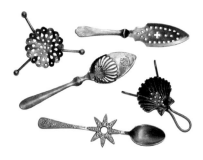

Rare antique spoons: Cuillères #6 'long' spoon
can be used for the burn method; Les Grilles
#9 and Coquille Saint Jacques 'round' spoon;
Le Croix Suisse spoon; and original Toulouse-
Lautrec spoon believed to be owned by the
artist himself
(Note: the number classifications refer to
Marie-Claude Delahaye's book, *Les Cuillères*)

*Spoons*

Absinthe spoons exhibit numerous holes or decorative openings by which the water drips through the sugar cube and into the reservoir of absinthe. Many of the basic designs consist of trowel-shaped spoons with numerous holes of familiar shapes. The most commonly encountered designs are pipes (les pipes), arrows (les flèches), stars (les étoiles), clovers or clubs (les trèfles), crosses (les croix), circles (les cercles), diamonds (les diamants), round (les rond), and flowers (les fleures).

Occasionally, a spoon of unusual shape and/or design surfaces, which sometimes makes it difficult to determine if the spoon was in fact an absinthe spoon. The holes must not be too tiny (or too large) and the shape of the handle or spoon portion must not dip too low or curve too severely as to cause an imbalance. Oftentimes, spoons intended for sugar, flour, olives, mulberries, mote (skimming tea leaves), nuts, bon-bons, or even ice may be mistaken for a rare absinthe spoon.

The prices of absinthe spoons typically range from $20 to $3,000 USD (U.S. dollars), depending upon style, condition, and rarity. The most highly sought antique spoons would be the Toulouse-Lautrec, Le Tour Eiffel, Coquille Saint Jacques, La Feuille d'Absinthe, and Absinthe Joanne, which all are extremely rare and equally expensive.

Genuine absinthe spoons were often made of silver-plated base metal, German silver, or other inexpensive alloy. The better quality spoons are molded, while the more common spoons are stamped. After a century, most spoons are usually worn, whereby the underlying metal is exposed. It should be noted that the appreciating value of the rarer spoons has spawned an industry of clever fakes. These fakes are frequently made of silver, silver plate, and sometimes brass. Very few original spoons were created in silver, simply because most spoons were usually used in cafés, where silver spoons would have wandered off with considerable frequency. In modern times, it is perhaps easier and less expensive to craft a fake from solid silver than to make it in brass or tin and subsequently have it silver-plated.

## Glassware

The immense popularity of absinthe lasted better than half a century, and its end roughly coincided with the dawn of the art deco era of the 1920s and 1930s. As can be expected, the styles of glassware evolved during the heyday of absinthe and there is some crossing over of glassware styles between the pre-ban and post-ban periods. Absinthe style glasses can be more or less divided into two categories: **1.** glasses that were used for absinthe, but were also used for other beverages; **2.** glasses that were exclusively used for absinthe.

The Swirl, Egg, Chopes Yvonne, Mazagran, Lyonnaise, and East styles of glassware typically fall into the first group. These glasses were general purpose bistro glasses. The ones used primarily for absinthe service are about six- to seven-inches tall. The smaller (five to five and one-half inches) Egg and Swirl glasses were used for other drinks as well, including coffee. The height and sturdiness of a glass is quite relevant. Remember that a significant volume of water (three to four times the volume of absinthe) is poured into the glass, thus glasses usually tend to be relatively voluminous. Likewise, many of these glasses were intended for use in rowdy bistros, so the glass was made sturdily enough to withstand frequent use and abuse. Crystal glasses, glasses with gold rims, or light, thin glasses are not absinthe glasses.

Cordon, Reservoir, and Pontarlier style glasses fall into the second category, and were only used for absinthe. These are far more rare, and, of course, more expensive than other glasses. These glasses are generally not very tall, being usually in the five- to seven-inch range.

Some of the more interesting absinthe glasses are Reservoir glasses, which come in different variations of size and depth. For a glass to qualify as a true absinthe Reservoir glass (and its corresponding price justification), the bowl of the glass must be clearly defined and not just consist of a slight narrowing of the bowl at the base.

Cordon glasses are among the rarest of the glasses. They are easy to recognize, as the "cordon" is a ridge or tubular ring of glass around the bottom of the glass that

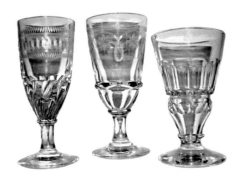

Rare antique glasses: Etched Swirl, Etched Cordon, and Pontarlier

Glowing green antique swirl glass, whose production was halted due to the dangerous presence of uranium within the glass

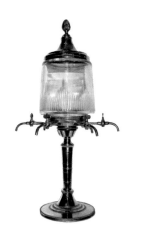

French six spigot, faceted antique fountain, 1900

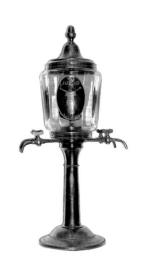

French Junod Pastis fountain, 1930

marks the dose. All Cordon glasses were intended for absinthe use and the style does not appear to persist into the post-ban era. Apparently, only one or two glassworks made Cordon glasses, which is why there is relatively little variation in the design.

Pontarlier glasses are extremely rare and most desirable of the absinthe glasses. The elegantly cut reservoir serves as a separate, clearly defined chamber beneath the main part of the glass. The only glasses rarer than the Pontarlier and Cordon styles are those with advertisements and perhaps the green- or blue-tinted swirl glasses. Many advertising glasses are post-ban items, so the collector should be forewarned. It is interesting to note that many green glass items from the period were made from sands that contained traces of uranium compounds, which caused the glass to give an eerie fluorescence under black light.

When scrutinizing an absinthe glass, the bottom of the glass should be inspected for the circle where the glass was broken off (in the process of hand blowing). It should not be symmetrical or perfectly circular in shape. Also, scratches are usually evident on the bottom of the base, as a result of the glass being pushed across marble-topped bars and tables. Likewise, many glasses contain numerous light, small scratches on the inside bottom, where the spoon was used to stir the sugared absinthe. The going rate ranges from $20 to $400 USD.

*Fountains*

Absinthe fountains are elegant and mesmerizing focal points for the absinthe service set, and a seemingly essential luxury. Fountains were made of metal and glass with two to six robinettes (tiny faucets or spigots). Upon filling the fountain with cold water, the imbiber simply places a glass under one of the robinettes and turns the tiny spigot, dripping the ice water into the waiting glass.

The price for genuine absinthe fountains varies, surging from $1,500 to $8,000 USD. Some of the most collectible fountains are those etched with publicity names of absinthes. The Absinthe Terminus Bienfaisante fountain, with a rooster perched on the lid, is perhaps the most famous example. The Legler Pernod and Absinthe Bailly pieces are also fine examples of advertising fountains.

Most antique fountains were used regularly (and roughly) in the bistros, as most are not in superb shape. Many are dented, with broken lids and glass. Genuine absinthe fountains also tend to be smaller at the top of the glass reservoir and larger at the bottom, while the post-ban fountains tend to be the reverse. Also, the robinette handles of absinthe fountains usually take the shape of half of a cloverleaf, while the post-ban robinette handles tend to be slender and have a rectangular shape. The very clever rounded metal and glass fountains manufactured during the art deco period (after 1920) are lovely, and are usually priced just a bit lower than genuine absinthe fountains.

Absinthe Francaise match striker

## Match Strikers

Match strikers are called Pyrogènes in France, simply because Pyrogène was one of the most prevalent manufacturers of these items. These objects typically consist of a glazed porcelain table item that is about the size of a clenched fist and is usually both cylindrical and conical in shape. The match striker has a cylindrical well in the center, which is used to store wooded matches. The sloped edges of the conical relief of the object have sharp ridges that serve as a rough surface upon which matches are stricken. Match strikers are desirable objects for any collector who wishes to create a period bistro table setting.

Some match strikers are adorned with a glazed advertisement for a brand of liquor. These advertisements usually consist of a brightly colored verbal proclamation of a specific product that spans the circumference of the match striker. Those with advertisements for a certain brand of absinthe are, of course, far more expensive than the others. Many match strikers with absinthe advertisements fetch between $350 and $1,200 USD, which is often determined by the beauty, condition, and rarity of the piece. If the word "absinthe" does not appear on the item, do not pay too much for it.

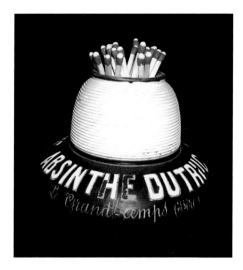

Absinthe Dutroc match striker

The Royer Hutin match striker appears to be by far the most commonly encountered. The cobalt blue match strikers, often auctioned on the web, are almost always fakes, as are most of the Absinthe Mugnier strikers. Wooden and

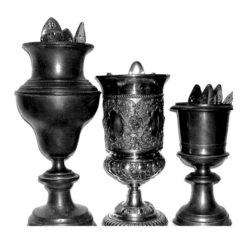

Antique spoon vases, also known as *troncs*

Metal sugar (*sucre*) dish

glazed strikers are more desirable and valuable than those made of brass and such. Absinthe Dutruc and Oxygénée (standard types—there are several, very rare variations) are also commonly encountered. If it is seriously chipped, its value is greatly diminished (some missing enamel or faded lettering is acceptable, albeit at a reduced price). The most desirable and most expensive match strikers are, of course, those that feature striking design and vivid colors.

## Spoon Vases

The tall metal spoon vases, *troncs*, were typically made of heavy pewter or brass, and typically resemble small, ornate flower vases. Genuine spoon vases usually have elegant curves and a stately pose. One type is cleverly constructed with a removable inner cup, whereby the café dishwasher could remove the cup and dump the spoons into the sink in order to wash the utensils.

The collector should be advised that disreputable vendors have offered spittoons and flower vases as absinthe spoon vases. When loaded, the spoons should protrude from the mouth of the vase, and the diameter of the mouth should not be too wide. The prices for genuine, documented absinthe spoon vases will usually vary from $300 to $1,000 USD.

## Sugar Dishes

Metal or glass, small or tall, sugar dishes were used to hold the long, rectangular sugar tablets of the period. These dishes were not all related to drinking absinthe, but were also used for coffee, chocolate, or tea. The smallest metal sugar holds about three tablets, while the largest dish is mounted on a large pedestal and can support a small army of absinthe drinkers. The name of the manufacturer is sometimes stamped along the edge of the dish. Prices for sugar dishes typical range from $30 to $100 USD.

## Saucers

Saucers were usually made of ceramic or bakelite, and were placed underneath just about any drink one would receive in a café or bistro. Since bakelite was not invented until 1910, bakelite saucers would likely be post-ban items. Most period saucers are ceramic and many feature a price that is conspicuously painted near the rim.

Historically, a new saucer was served with each drink, and, naturally, the price of the saucer indicated the price of the drink. The price of a glass of absinthe in France started around ten centimes (cents) in 1880, followed by twenty centimes around 1890, jumping to fifty centimes in 1900, and finally ended up at several francs by 1915. Therefore, the price listed on the saucer is somewhat indicative of its age. Bakelite saucers are rarer now, but the ceramic ones are more collectible.

Some saucers have multiple colors, others are rimmed with gold and many have embossed or raised designs in the center. The undersides of many saucers are stamped with the name of the manufacturer. Based on the age, condition, and rarity, saucers fetch a price between $10 and $45 USD.

## Topettes

Topettes are small- to medium-sized glass bottles with an inverted conical shape. Many have numerous measuring marks or bulging ripples that run up the side of the bottle, which serve as volumetric indicators. The purpose of a topette was to provide efficiency and convenience for both the wait staff and patrons. If a group of persons were all drinking absinthe, the waiter would simply bring a topette containing anywhere from four to twelve pours of the liquor. The graduated marks or ripples in the topette made refilling absinthe glasses with measured pours relatively easy for the imbibers.

Perhaps the most inviting topettes are the ones that have the word "absinthe" etched in the glass, while others just have etched dose cuts, numbered one through six, or the usual ripples. Most topettes are clear or absent of color, some rare ones are a pale green, while others feature a dark brown or deep green tint.

Various saucers showing the range of pricing, style, and color

Antique crystal topette

La Cressonnee glass water carafe

**MODERN OBJECTS**

Reproduction spoons, glasses, and various other absinthe items are currently filling a void where certain original items are exceedingly rare and equally costly. Many of the modern items are lovely, shiny, sturdy, and mimic the original examples. There is nothing wrong in selling a reproduction, so long as it is sold as a contemporary item. Unfortunately, there is no shortage of less-than-honest dealers who offer modern reproductions as antiques. It is always advisable to know something about the reputation of the seller before jumping into a purchase of an item for which a reproduction is known to exist. Likewise, be certain it is openly agreed that the seller promises to replace items that are chipped, broken, or even lost in transit.

All topettes came with a bouchon (top), so if the glass stopper is missing (and many are), the topette is not a complete item. One can usually purchase a topette somewhere between $75 and $200 USD.

*Carafes*
Carafes are large, expansive water carriers used to hold the chilled water for absinthe service. Carafes do not have bouchons, as the mouth is narrow with a lip that curves widely to make for the tidy pouring of water. Some of the rarer, fancier carafes even have a separate, enclosed well just to contain ice. The price range for an antique carafe is $100 to $400 USD.

Like match strikers, because carafes were always in plain view of the patrons, many carried advertisements screened on or etched into the glass. Many of these advertisements consisted of verbiage to promote a liquor or manufacturer thereof, while some are quite picturesque, featuring captivating color images. For example, the Absinthe Bourgeois carafe (from the distillery and absinthe of the same name) features an illustration of a cat happily lapping from a glass of absinthe.

While some carafes are definitely pre-ban items, many are not, and this tends to cause confusion. Some carafe producers, such as Berger, continued to make absinthe after the ban, so a carafe that features an advertisement for the name of an absinthe producer may actually be a later item that was intended to promote a different product.

## ABSINTHE ADVERTISED

As the Age of Impressionism was coming to an end in the 1880s and 1890s, consumers in Europe and America were being treated to a new form of advertising, which was also a new form of art—the illustrated, color advertising poster. The boulevards of Paris, the tiny streets of Belgium and Holland, and the squares and shop windows of America suddenly came alive with colorful images.

*Lithographic Poster Art*

In 1878, a German named Alloys Senefelder created the printing method known as lithography, named from the Greek word *lithos* (stone). The ink is carried on a flat surface rather than on raised edges or incised lines. Jules Cheret would refine the lithographic printing technique several years later.

Cheret is rightly recognized as the father of poster art, and is said to have designed more than 1,000 posters. The great artists of Paris followed this lead into the poster movement, lending designs frequently influenced by Japanese woodcuts. The notable group of artists led by Cheret included masters such as Théophile Alexandre Steinlen, Eugène Grasset, Pierre Bonnard, Adolphe Leon Willette, Jean-Louis Forain, and, perhaps the most famous of them all, Henri de Toulouse-Lautrec.

The golden era of advertising posters emerged as the Industrial Revolution was in full swing. Once basic needs like food and shelter were satisfied, consumers oftentimes succumbed to these seductive ads, investing their surplus into the fashionable vices of the day. Posters were an inexpensive and visual means to lure consumers into desiring anything from a bottle of liquor to a fancy new hat.

Posters for alcoholic beverages provide a fine example of art leading the way toward breaking social taboos. In the nineteenth century, drinking by women was commonly regarded with scorn. As a result, traditional liquor ads were targeted almost exclusively toward men. Knowing how red blooded men tend to be seduced by a pretty face and voluptuous figure, the poster artists effectively exploited the imagery of women in liquor posters, which sometimes illustrated

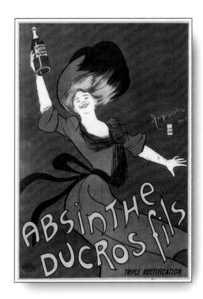

**ABSINTHE DUCROS FILS, 1901**

This woman in red is absolutely brimming with joy. Her wide smile and flaming red dress is trimmed with black. The obscure dark background is not despairing, but merely a contrast to more dramatically display her exuberance for life. Her supple body is quite expressive, as she appears to be leaping or dancing into the air. One hand holds the bottle of absinthe and the other swings loose and empty handed. She is both free and wild.

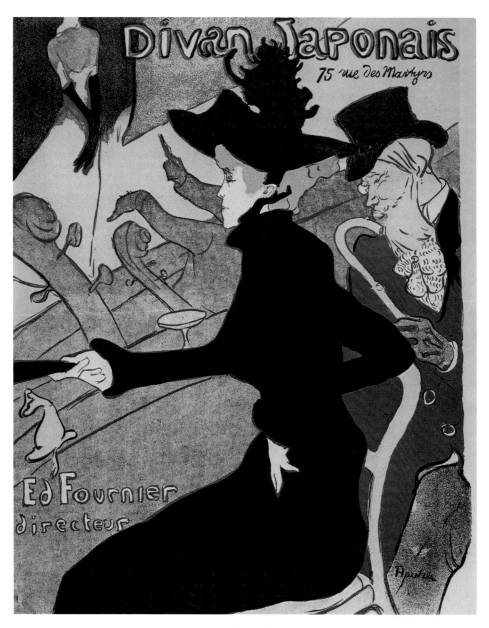

*Divan Japonais* by Toulouse-Lautrec

the female subjects not only admiring the product in question, but actually imbibing it (such as Dubonnet, Vin Mariani, Absinthe Robette, and Mumm Champagne). With theater actress Sarah Bernhardt's poster art debut, other female stars began gracing some of the most beautiful posters ever created. Striking images of Yvette Guibert, Eugenie Buffet, Camille Stefani, Jane Avril, La Goulue, and Loie Fuller are forever immortalized in Belle Époque poster advertisements.

A Sunday afternoon ritual for the folk of Paris was to journey to the dance halls atop the butte of Montmartre, to drink wine and dance. The Moulin Rouge opened there in 1899. With Montmartre being home to as many artists as cabarets, the quality of entertainment posters was fabulous. Toulouse-Lautrec spent his most prolific and creative years just a stroll away from the nightspots he frequently haunted. Poster images were created for venues such as the Moulin Rouge, Folies-Bergere, Olympia, Theâtre de l'Opera, and Jardin de Paris, to name but a few.

During the heyday, posters were issued through the print dealer Sagot in the 1890s, posters such as Toulouse-Lautrec's "La Revue Blanche" sold for a paltry five francs. Original examples of this poster have recently sold in auction houses for more than $40,000 USD. And Toulouse-Lautrec's "La Goulue" went for $250,000 USD! These and other works of the period continue to rise in value. Posters that were created as small, artistic advertisements are now valuable art unto themselves. However, original posters are typically priced anywhere from $1,000 to $10,000 USD.

In early lithographic posters, the artist or an assistant would draw the image onto a slab of limestone using a grease crayon. Most posters were actually drawn on the stone or plate by a master lithographer, albeit with the guidance and approval of the artist. It is difficult to realize what a cumbersome, exacting process stone lithography really was. There were major drawbacks associated with the art of lithography. The limestone was most often Bavarian limestone, which was heavy, fragile, and expensive. In addition, a separate stone was needed for each different color of the poster. Therefore, sometimes as many as nine or ten stones were used for one poster.

After the ink was applied to the stone, the paper was laid onto the stone and a metal backing was laid on top. The entire stone passed on runners under a wooden bar called a scraper, which applied pressure to lift the ink from the stone to the paper. The process had to be repeated for each color. When the printing run was completed, the stones were often ground down and reused for the next poster.

Commercial printers began using roughened zinc plates instead of limestone, which concurrently began to be known as lithographs. One distinctive feature of most original lithographs is the evenness with which the ink is applied to the paper. Under a magnifying glass, you can see that the colors are evenly distributed. This detail provides one method of identifying a poster as a genuine lithograph as opposed to a recently printed photo offset reproduction of a lithograph (which has a visible finely dotted matrix).

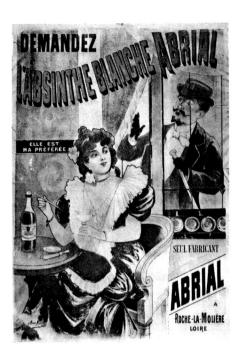

**BUVARD, date unknown**
This very rare Buvard has an unknown date of origin. The pastel blue/gray mono color blotter picture was an advertisement for Abrial, a French distillery. The stunning, dark-eyed woman sits at a table with her glass, spoon, sugar, and bottle of absinthe. A handsome, well-dressed man is outside the window seeking her attention and, motioning to her with a gloved hand, is ready to rap the window with his cane. She looks at him but with cigarette in one hand and drink in the other, the lady makes no move to open the door. The caption actually reads that she "prefers absinthe."

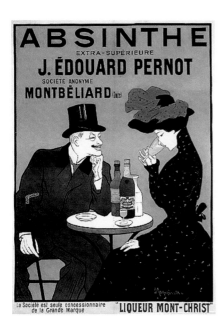

**ABSINTHE EDOUARD PERNOT, 1896**
Wearing a tall top hat and toting a cane
(phallic symbols in the psychology of art),
the mustached man with a monocle is
intently peering at the timid woman who
seems unable to return his penetrating gaze.
Instead, she is timidly gazing downward
while tentatively sipping the absinthe. Two
saucers are on the table. However, both
glasses are in her possession: one is small,
perhaps containing liqueur, and lies on the
saucer, while the absinthe glass is pressed to
her tightly closed lips.

Dressed with both wrists and neck
covered by clothing as if hiding her
charms, she innocently flaunts one wild,
red scarf that waves out of the brim of her
hat. Apparently the older man, grinning
lasciviously, desires to watch her initiate a
sip into the world of absinthe, watching for
the impact of the drink.

*Additional Absinthe Ads*

Engravings, also known as gravés, were drawings cut into a metal plate or
wooden block, which were then coated with ink, and then pressed onto paper with
a printing press. In addition to other uses, engravings were used as vehicles for
advertisements. They are often characterized by hand-carved lines that give the
etching a unique, sketched look. Most antique engravings were made with black,
brown, or blue ink, as these colors were the most readily available at the time.

Buvard is the French word for blotting paper, which was used to quickly dry
a freshly written letter by absorbing excess ink. A typical buvard was simply a
piece of thick, absorbent paper that was placed over wet ink. Buvards seem to
have endless absorption capacity, and can last for 100 years or more.

Although buvards first became popular around the 1850s, it was not until the
1860s that clever advertisers realized that these ink blotters made for a very good
advertising tool. The advertising imprint varied from simple monochromatic
prints to very striking full-color ads.

A carton was a heavy, inflexible thick paperboard, not unlike that used in the
making of cardboard boxes today. Very nice cartons that advertised absinthe,
other liquors, and the producers thereof frequently adorned bistro walls. Ads
for popular tipples such as Byrrh, Suze, Oxygénée, Picon, and Berger were
common. Some of these ads were not made of cardboard, but were made of
enameled metal. These more robust items were both heavier and more durable,
and were generally posted outside the restaurants and bars.

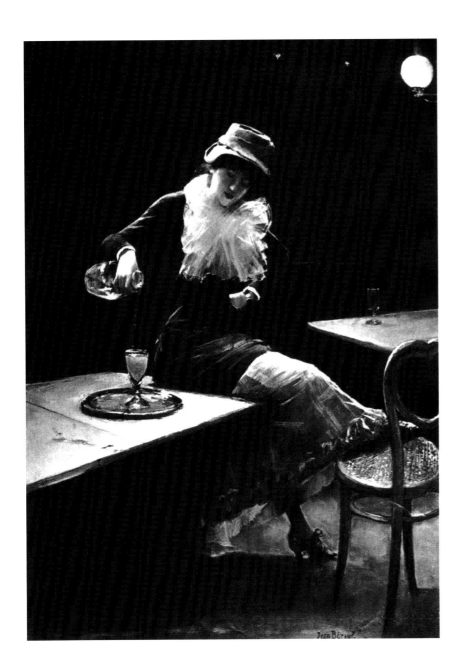

**L'ABSINTHE, BY JEAN BERAUD; THE ENGRAVER IS A. LERAY, 1882**

This detailed black-and-white engraving carries a sense of elegance as well as subtle sexuality. The woman, totally composed and serene, intently pours water from the carafe into the glass of absinthe. She displays one slender ankle, always a sexual allusion.

On the other table lies an empty glass and there sits no drinker. The bar surroundings are stark and dismal with the exception of her. She is the center of attention, dressed up in lavish, expensive clothes. Her presence in the center of the picture is riveting, and her demeanor is essentially intense upon the task at hand.

The title of this vividly colorful and unusual French postcard is "Une Absinthe Irrésistible." The woman is using an absinthe spray to lure the man who is fondling another woman. Notice the semi-clad presentation of the woman, as well as the red chair in her boudoir. Many postcards and posters were provocative but this particular picture reveals the female's breasts.

## Postcards

Many French collectors have a fixation on antique postcards (*cartes postales*), which are often picturesque, beautiful, and even humorous. The French are big collectors of postcards, and those that offer satirical illustrations regarding the evils of absinthe are especially desirable. Full-color absinthe advertising cards can be expected to fetch more than $100 USD each, while black-and-white cards fetch a bit less at $50 to $60 USD. The prices for black-and-white cards that are part of a numbered series typically range anywhere from $30 to $170 USD each, depending on condition and rarity.

The numbered series of the twenty-eight black-and-white Pernod Fils absinthe distillery postcards are among the most famous and collectible. There is also an unnumbered Pontarlier series that includes some photos of the Pernod facility, but these are not quite as desirable as those issued by Pernod Fils. The Pernod Fils distillery series includes photos of bottles, warehouses, women laboriously filling the bottles, sturdy laborers loading the bottles onto trucks, and other snapshots of the production process. Some postcards even provide actual photographic footage of the Pernod Fils distillery burning down in 1902. Pernod Fils also issued beautiful color cards, but most of these are post-ban issues.

Several of the numbered postcard series from the period are intended to be novelties based upon various absinthe themes (e.g., animals, babies, cartoon figures, etc.), and can be pieced together sequentially to display a complete short story of images. One particular series, the unofficially named "Bebe Absinthe" set consists of six cards. The child in this story is a little boy, who, while his grandfather is away, reads the newspaper, prepares himself a Pernod absinthe, and smokes a cigar! As politically incorrect as it may seem, children were often enlisted in alcohol-related advertisements. Indeed there are postcards of babies holding absinthe when they should have been clinging to milk bottles.

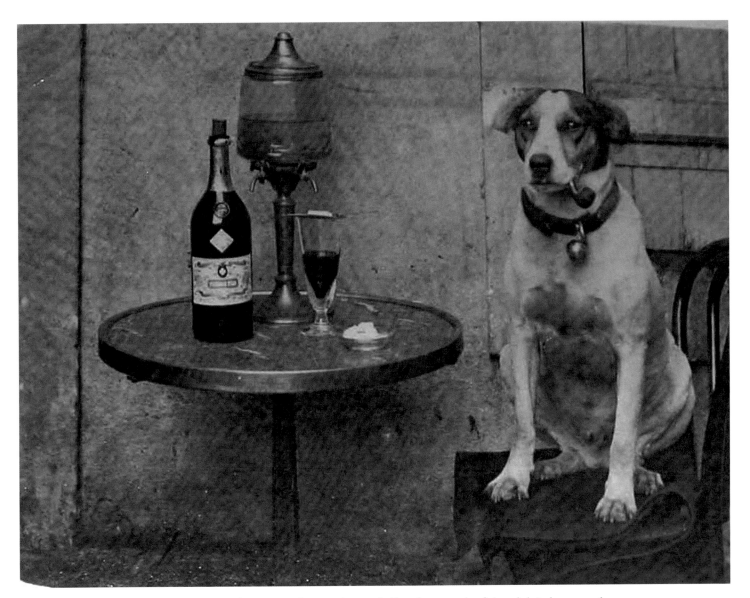

The dog is apparently waiting to be served Pernod Fils, a fine example of absurd absinthe postcards

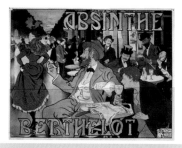

**ABSINTHE BERTHOLET, 1895**
This poster is full of vibrant life. The drinker is gazing at a shapely woman who has intentionally pulled up her ruffled skirt to display her ankles as she is strolling by. She meets his gaze and turns back toward him. He is so entranced that he obliviously continues to pour the water into the absinthe glass; also not noticing that a young prankster is pulling the glass away and drinking the absinthe. Males gazing at him from another corner of the bistro smile in amusement.

**CAUTION TO THE BUYER**
Do not assume that the brown-tinted paper of a document and/or postcard is evidence of the item's antiquity. In fact, this "foxing" can be due to the presence of a brown fungal growth. Not only can this mislead the inexperienced collector, but it also may present a danger to any nearby paper collection. While some light mold can be brushed off, affected items should be stored separately in sealed bags to prevent the possibility of spreading to the entire collection.

## RESTORATION VERSUS PRESERVATION OF PAPER ANTIQUITIES

Most absinthe posters were plastered along popular streets and in train stations, exposed to the elements. Of those posted in bistros, many are not in fine condition, as crowded smoky bars were not quite an environmentally ideal location pursuant to the preservation of paper or the lithographic inks.

Any damage at all, whether from creasing, fading, or slight tearing can be expected to decrease the value to some degree. Basically, the older and more pristine the condition of the paper item, the more value it carries. But there are options if the image is badly ripped or has holes. However, an ongoing debate exists with respect to preservation versus restoration of original posters.

On one hand you have preservation, which can be a bit costly, but is the most frequent recommendation. If you can find a local archival preservationist, it tends to simplify matters. The preservationist de-acidifies (makes pH neutral) the item, encapsulates it (encloses it in an acid-free polymer envelope or sheets) or wraps it in acid free tissue paper, and then places the item in an archival flat box with reinforced corners. For those who prefer to perform their own work, you would need to purchase de-acidification spray, archival photo pages, pH neutral tissue paper, and photo boxes. Hanging precious items and flaunting them for all to see is generally desirable, but if the image receives prolonged exposure to direct light it may fade.

However, on the other hand you have restoration, which is a serious, invasive option for deteriorated artwork. New technology enables the use of chemicals to clean the image of acid, dirt, and pollution from years of exposure. The restoration artist can even weave authentic, old paper into the torn edges to match the image and fill in holes. Color can then be added where needed with authentic-type inks and materials. This is a very tedious, time consuming, and a justifiably costly process that has no guarantees.

**ABSINTHE ROBETTE, 1896**

More than merely suggestive, the woman with the fawn-colored hair and upraised arms holding the glass with open hands is essentially nude. The transparent gown reveals her breasts and the pastel greens surround her subtle smile while wormwood leaves line the poster outline.

The temptress is offering the glass with sugar and spoon to another unseen being who is above her, and who is slowly pouring the water while she clasps the receiving glass. Receptive and seductive, this woman portrays the pique of responsive waiting. She knows all about the subtleties of the relaxed ritual of drinking absinthe and seems to want whatever may follow with graceful yet innocent abandon.

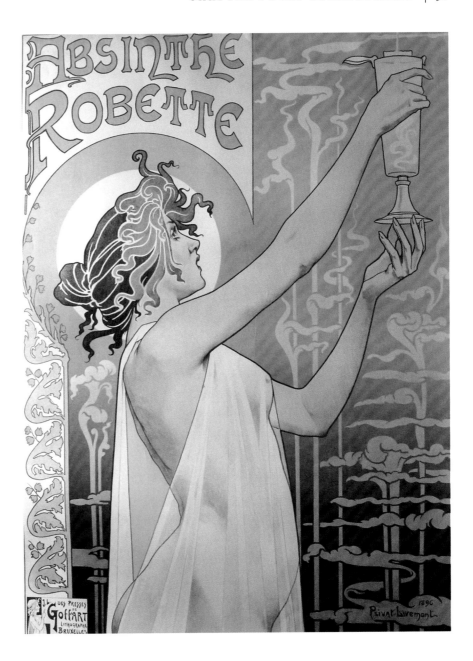

# CHAPTER 5

## *The Reviews Are In*

### AN EDUCATION ON CONTEMPORARY ABSINTHE

*I*t is imperative to preface this chapter by advising the reader that the quality of modern absinthes is as varied as that of modern wine, ranging from excellent to downright deplorable. Unlike modern vintners, however, the vast majority of modern absinthe makers are only recently associated with the liquor (despite frequent claims to the contrary) and possess very little experience or history with the liquor beyond that which they may have read in contemporary musings. As a result, most modern products are purely recent inventions, and most present only a slight resemblance to the famous absinthes that were immortalized during the Belle Époque.

A scant few modern absinthes are made using the more expensive traditional methods, but the vast majority are made from simple herbal extractions and/or commercial oils, and frequently contain a variety of artificial colors and additives. Many of these cheaper (in quality) brands are priced as much or even far greater than the better products, so caveat emptor. In any case, you are better off by dismissing much of the romantic propaganda found on distributor websites and seeking educated feedback from objective sources.

(Opposite) *Keeping the Demons at Bay* by Marc Meloche

## ABSINTHE AND THE INTERNET

For American buyers, procuring absinthe online carries some risk of loss. All the importers are domiciled outside the United States, and therefore packages containing absinthe must pass through customs before entering the country. Because the importation of absinthe is prohibited, there is a chance the merchandise will be searched, seized, and destroyed.

Purchasing absinthe via foreign importers is done so at the buyer's risk. For those who conspire to do so, it must be stressed again that it is best to do some homework beforehand. There are several third-party websites that provide some insight as to what you can expect from the various brands of absinthe (see Appendix). While it is common for distributors to make lofty claims about their wares, finding a product that offers some semblance of quality is a matter of consumer education. Some products are bitter, some are sweet, some are green, others crystal clear, some are tasty, and some are downright nasty. It is always a good idea to find out as much as possible about a specific importer, including shipping fees, customer references, special offers (some companies offer volume customers a free ritual spoon or spiffy t-shirt), as well as the expected delivery time in advance of placing an order.

## THE REVIEWS

While the absinthes reviewed briefly herein are only a fraction of what is currently available, they represent perhaps the most visible and/or significant examples in the market at the time of this writing. This brief selection includes brands that are considered as 'better,' as well as those typically considered as 'lesser,' so just because a particular brand is listed here, it should not be considered as an endorsement by the authors of this book. Intentionally omitted are faux absinthes that are distributed (legally) in the U.S. and elsewhere.

Where available, the website of the producer or sole distributor has been provided for each product. For the retail purchase of absinthe, the reader should visit www.feeverte.net/absinthe-guide.html, where a variety of absinthe distributors can be sourced for many different absinthes. The list is in alphabetical order.

## Absinthe Nouvelle-Orléans

68 percent alc, 75 cL
Jade Liqueurs, Ltd.
*www.bestabsinthe.com*

Jade Liqueurs was founded by a group of American absinthe historians and scientists in an effort to recreate the Belle Époque era absinthes with absolute historical authenticity. The Jade absinthes are purported to be marques of authenticity and quality and are available in limited supply. The sample submitted for this evaluation is known as Absinthe Nouvelle-Orléans.

This absinthe is a light vibrant green color, giving a nose that is soft and spicy, with distinct floral notes. The liquor yields a strong louche upon the addition of water. The light aroma of the resultant mixture is deceiving, as the flavor yields a stout complexity of successive textures. The anise is surpassed by a potent spice that yields to a brief, mildly bitter finish, followed by soft aromatic notes that linger on the palate for several minutes. This finely crafted absinthe is as stimulating as it is unique.

**Absinth Ordinaire**
70 percent alc, 70 cl
G. F. Ulex Nachfolger
Neuhaus, Germany
*www.ulex.de*

The resurgence in the popularity of absinthe has gradually spread into Germany, where several absinthes of varying quality have popped up. One of the first German absinthes to be released was Absinth Ordinaire, made by G. F. Ulex, which is a long-standing maker of various liqueurs and cordials.

Absinth Ordinaire has a light olive tint, and gives an aroma of both high- and low-pitched herbal notes that ride a moderate wave of alcohol. The flavor of this strong spirit is somewhat light, giving firm bitter notes with a mild background of anise, and louches moderately upon the addition of water. This product lives up to its claim 'bitter spirituosen' (bitter spirits), and while it lies more toward the style of a bitter aperitif than a traditional absinthe, it is relatively palatable.

## Deva Absenta

70 percent and 45 percent alc, 70 cl and 1L respectively
Destilería La Vallesana, S. A.
Barcelona, Spain

This brand gained popularity in the late 1990s as a low cost, easily obtainable, more traditional alternative to the untraditional Czech brands that were being heavily marketed at the time. Originally only the 45 percent version was available, with the 70 percent version being introduced sometime later. The label on the Deva 70 percent bottle is distinctly different than that of the 45 percent version and features two elegant art nouveau green fairies sensuously interacting with each other, which is a rendition of the 1890 painting *When Hearts Were Trumps,* by the American artist Will Bradley. In lieu of the plate of grapes depicted in the original artwork, the person is offering a platter that holds two glasses and a bottle.

Deva 70 percent is light green in color and gives an aroma of anise with distinct oily, earthy undertones. Its flavor consists of a large alcoholic kick, followed by a fairly strong dose of anise, and ending with an earthy, oily texture. Deva louches readily upon the addition of cold water and is similar in texture to some modern liqueurs d'anise. Deva gives a relatively simple, straightforward anise flavor, accompanied by a tinge of lingering bitterness.

**Emile Pernot**

68 percent and 45 percent alc, 70 cl
Les Fils d'Emile Pernot
Pontarlier, France
*http://www.absintheonline.com*

The distillery of Emile Pernot survives as a remnant of the once thriving absinthe industry of Pontarlier, France. Originally founded in 1890 as Parrot Fils, the distillery of Emile Pernot quietly pressed on over the years, making a locally distributed liqueur d'anise and a few other locally popular liqueurs and cordials. Today, the founder's great grandson offers several different absinthes, including the flagship product Emile 68, Emile 45 La Blanche (a clear absinthe), and even an absinthe-based sapin aperitif. The absinthes are made in the distillery's original antique alambic stills.

The color of Emile 68 is a very light amber hue. The aroma of anise is prevalent, being accompanied by a fair bit of heat. Following right behind is a background mix of subtle, darker lacquer notes. When diluted with water, the resulting liquid louches moderately, yielding heavy gradient lines that swirl around the glass. The flavor offers a moderate dose of heat along with a spicy but dry accompaniment of anise. The taste of this absinthe is one that is crisp and refreshing, giving a fairly strong, dry anise flavor with just a slight dry bitterness in the finish. Emile 45 is similar, being equally pleasant albeit sans the subtle lacquer notes, which gives it a bit of a cleaner, refreshing finish.

## François Guy

45 percent alc,1L
Distillerie Pierre Guy, S.A.R.L.
Pontarlier, France
*www.pontarlier-anis.com/uk*

Historically similar to Emile Pernot, the distillery of Pierre Guy is a remnant of the glory days of absinthe production in Pontarlier, France. Originally founded as Distillerie Armand Guy, the small distillery also survived by distributing liqueur d'anise. Today, the distillery offers an absinthe of 45 percent, and, also like Emile Pernot, uses antique alambic stills.

The aroma of François Guy is pleasant, being somewhat aromatic and woody. This absinthe is virtually clear, featuring just the slightest dark amber tinge. François Guy louches well upon the addition of water, and the flavor remains simple and refreshing, being neither thin nor heavy, with supple dark woodiness making its presence known with every sip. This absinthe is easy to drink and palatable, yielding but a mildly bitter flavor.

**Hill's Absinth**

70 percent alc, 70 cl
Hill's Liqueur
Jindrichuv Hradec, Czech Republic
*www.eabsinthe.com*

Although representing perhaps one of the furthest departures from a traditional absinthe, the effective marketing of Hill's (primarily in the United Kingdom) is credited with sparking the modern resurgence in the popularity of absinthe. Because the consumer typically finds the traditional French ritual to be relatively useless with this product, distributors of Hill's promoted a Czech burning ritual in an apparent attempt to make the drink more interesting.

Hill's bright blue-green coloring is perhaps the most vivid aspect of this liquor. The aroma is strongly alcoholic and is accompanied by a peculiar sweetness. The flavor is thin and lacking, consisting of mostly a strong alcoholic kick with perhaps a touch of earth that lies behind a sugary veil. Very little anise (if any) is present, and Hill's does not louche in the traditional fashion when water is added. Perhaps it is because the Czechs are generally not fond of anise that this product is indeed a strange one, with no apparent connection to traditional absinthe.

## Kübler Absinthe

57 percent and 45 percent alc, 1L
Distillerie Kübler & Wyss
Môtiers, Switzerland
*www.blackmint.ch*

Distillerie Kübler & Wyss has a history that goes back to 1935, when the company became engaged in providing essential oils and fruit syrups to industry. The company continues to provide these products until this day. Recently, the company has engaged in making an absinthe, undoubtedly in an attempt to provide a commercial representative of the clandestine La Bleues that are made in the region, typically by local farmers.

Kübler 57 is opaque, being not quite clear due to a slight tinge of brown. The aroma is only mildly alcoholic in nature and carries mildly nutty notes. The liquor louches relatively well upon the addition of water, the resultant mixture yielding a relatively light anise flavor that is sharply contrasted by strong, darker, burnt undertones that are almost overwhelming. Kübler does not exhibit the finesse and balance of better clandestine La Bleues, although it is rumored that an improved version is now available.

**La Fée Absinthe**
68 percent and 45 percent alc, 70 cl
Producer Unknown
Paris, France
*www.eabsinthe.com*

La Fée is made in France but is distributed only by the United Kingdom based company, Green Bohemia. Green Bohemia is credited with introducing Hill's Absinth into the U.K. market, but since aficionados of classic absinthe deride the Hill's brand (and Czech absinthes in general), Green Bohemia sought to broaden their offerings by introducing a product with a more traditional style and character.

La Fée is advertised as being based on an original nineteenth century protocol. Like the vast majority of modern absinthes, however, it contains the usual artificial colorants, and thus gives a dark, glowing green color that is rather cloying. The liquor louches relatively well, and delivers a dry, somewhat peppery flavor with a background of anise and distinct herbal textures. This product is somewhat similar to modern Pernod 68 absinthe, albeit with a slightly drier nature and a more complex finish.

## Marí Mayans Absenta

70 percent and 55 percent alc, 70 cl
Destilerías Marí Mayans de Ibiza
Ibiza
*www.marimayans.com*

Like Deva Absenta, Marí Mayans gained notoriety as an alternative to the Czech brands that were heavily marketed in the late 1990s, and was perhaps the first Iberian product to be widely marketed in the United Kingdom.

The appearance of Marí Mayans is somewhat of a 'radioactive' shade of green, which the manufacturer claims to be of natural origin. The aroma is more of anise than alcohol, despite the 70 percent alcoholic content of this product, and Marí Mayans louches strongly upon the addition of water. The flavor is simple and straightforward, consisting almost solely of a very strong dose of anise (almost to a 'black jellybean' confectionary texture), with just the slightest hint of earthy notes that lie faintly in the background.

**Oxygénée**
55 percent alc, 70 cl
Cusenier (Pernod-Ricard)
Paris, France
*www.pernod.fr*

Oxygénée was originally the name of an absinthe made by the Eugéne Cusenier Distillery in Ornans, France. Any parallels between the original and the new product almost certainly end there. Modern Oxygénée is made by a division of Pernod-Ricard, and quietly appeared in 2000.

The color of Oxygénée is a light olive hue. The bouquet is simple, consisting of light anise with mildly sweet notes. The liquor louches mildly upon the addition of water and gives a very simple, light anise flavor with just a hint of aromatic bitterness in the finish. The density of flavor is a bit on the thin side, so it should not be heavily diluted, but the pleasant flavor of this drink is very light and refreshing.

**Pernod 68**

68 percent alc, 1L
Pernod-Ricard, S. A.
Paris, France
*www.pernod.fr*

Although its Cusenier division's product Oxygénée appeared first (possibly to 'test the waters'), the Pernod-Ricard company recently released the first French absinthe to carry the Pernod name since 1915. Although the old Pernod Fils distillery was dismantled almost a century ago, it only makes sense for the modern company to wield its name in entering the absinthe market.

The greatest similarity between modern Pernod absinthe and its ancestor is perhaps in the name, as the modern product appears to be made differently, using modern manufacturing methods, artificial colors, and so on. Nevertheless, the modern product is a worthy competitor to contemporary Spanish-style absinthes. The color of Pernod 68 is a medium shade of olive green and the liquor gives an aroma of mostly alcohol. The liquor louches moderately well, and the flavor consists primarily of sharp, dark, and dry herbal notes with just a bit of underlying sweetness from the anise.

**Philip Lasala Absinthe**
50 percent alc, 1L
Destilerías del Penedés, S. A.
Barcelona, Spain

Like Deva Absenta, Philip Lasala Absinthe is a relatively low-cost brand that gained popularity in the late 1990s when there were very few alternatives to the relatively untraditional Czech absinthes that were being marketed at the time.

Philip Lasala Absinthe is yellow with a slight green tint. It has a scent that is alcoholic on first whiff, followed by anise and the distinct odor of lemon in the background. The lemon aroma is reminiscent of certain furniture polishes that contain lemon oil. When mixed with water, the resulting louche carries a yellow tint. The flavor of anise is almost overshadowed by the strong lemon notes. The texture of this absinthe has a distinctive oily quality that is common in many modern products.

## Sebor Absinth

60 percent, 55 percent alc, 50 cl
Distillery of Martin Sebor
Krasna Lipa, Czech Republic

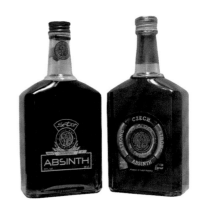

The Sebor firm is a maker of various flavored vodkas, gin, brandy, and cordials. Perhaps the second of the Czech absinths to be widely marketed in the United Kingdom, the distributors of Sebor have long sought to overtake their Czech competition (Hill's) in the U.K. market. Strangely enough, there seems to be a feuding of sorts between the distributors of Sebor, each of which declare theirs to be the only 'true' Sebor product. This tends to make things confusing for the consumer, so both versions were considered here.

The content of Sebor Absinth does indeed appear to vary, depending on the distributor. The version from the Czech distributor is lighter in color and has a lighter floral aroma, while the version from the U.K. distributor is darker and gives an oilier nose. The Czech 60 version louches lightly and gives a very mild anise flavor that is quickly subdued by fairly bitter herbal textures that linger on the palate. The U.K. 55 version louches similarly lightly and yields a flavor that is reminiscent of the Czech version, albeit with an added oily texture that imposes a rather bolstered bitterness to the drink. Sebor Absinth almost certainly represents the best Czech offering.

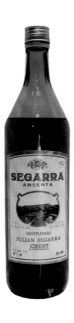

**Segarra Absenta**

45 percent alc, 1L
Destilierias de Julian Segarra
Chert, Spain
*http://lotobono.com/segarra/index.html*

Segarra Absenta is an artisanal absinthe produced by a small family distillery in rural Spain, known among connoisseurs for its fine brandy. The materials and methods employed by Julian Segarra represent an unquestionable throwback to earlier times, favoring grassroots quality well ahead of economic efficiency.

This absinthe has a golden amber color as a result of being stored in wooden brandy casks. The scent is mildly sweet and butterscotch in nature, which undoubtedly is due to remnants of leached brandy. The liquor louches nicely upon the addition of water, and has a nicely balanced flavor of anise that contrasts a distinct nutty confection and just a touch of lingering bitterness. Segarra Absenta is a nicely unique product that departs from the typical modern fare, and is perhaps the most interesting and unique of the Spanish absinthes.

**Suisse 'La Bleue'**
50 to 70 percent alc, typically 1L
Various Producers

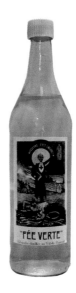

The term Suisse 'La Bleue' refers to any of several clandestine or "bootlegged" clear absinthes that are made in western Switzerland by rural folk. Following the Swiss government's decision to prohibit absinthe in 1910, some inhabitants in the Val-de-Travers area of the Canton of Neuchâtel continued to distill small batches of the liquor for their own use despite the threat of substantial penalties if caught. 'La Bleue' carries its own identity, typically being somewhat different in flavor and texture than the traditional French variety. Because these are clandestine products, the quality varies widely, ranging from somewhat disappointing to excellent depending on the skill of the maker.

The particular sample provided for the review was a finer representation of this category and was crystal clear with a clean, sweet bouquet of anise that was very light on the nose. It louched to a grayish opalescence upon the addition of water, with the flavor yielding a very light, refreshing anise flavor followed by subtle, aromatic herbal notes with a hint of orange and just a touch of lingering bitterness. This sample was very easy to drink, being both light in texture and refreshing, and appeared to be a more refined example of the typical Swiss bootlegs. The best la bleues are renowned for their smooth taste.

### Versinthe

45 percent alc, 70 cl
Liquoristerie de Provence
Venelles, France
*http://perso.wanadoo.fr/liquoristerie-provence/indexgb.htm*

Liquoristerie de Provence is a maker of herbal liqueurs and aperitifs from southern France. Curiously enough, Versinthe was originally marketed as anis amer (anise bitters) until fairly recently, when the maker decided to reclassify it as an absinthe. As far as what has changed (if anything) is unclear. Nevertheless, the maker also offers other products, L'amesinthe, which is extremely similar to Versinthe, and La Blânche, which is a clear product.

Versinthe is opaque, albeit with a brownish tinge. The aroma is pleasant and gives distinct earthy and spicy notes. The flavor consists of a dark, spicy headiness, followed by a distinct star anise texture that is masked by the obvious syrupy intrusion of sugar. While the presence of star anise creates a heavy louche upon the addition of water, the product is so sweet already that it is difficult to fathom the idea of adding more sugar as per the traditional ritual. Whereas its syrupy texture is not that of a traditional absinthe, Versinthe is reminiscent of a more aromatic modern liqueur d'anise.

**Additional Absinthe Brands**

Abisinthe, 72 percent alc

Absenta Serpis, 55 percent alc, 70 percent alc

Absenta Tunel, 70 percent alc

Absente Absinthe Refined, 55 percent alc

Absente Extreme, 70 percent alc

Absinth King, 60 percent alc, 70 percent alc

Absinthe Dedo, 75 percent alc

Absinthe N. S., 55 percent alc, 70 percent alc

Absinthe Original, 70 percent alc

Absinthe Pilsner-lor, 70 percent alc

Absinthe Schulz, 60 percent alc

Absinthe Trenet, 60 percent alc

Absinthus, 55 percent alc

Absinto Camargo, 54 percent alc

Alandia Boheme, 50 percent alc

Boyer, 50 percent alc

Cami, 66 percent alc

Chateau Saint Ferran, 70 percent alc

Elixir, 70 percent alc

Fleur de Lis, 55 percent alc

Fruko Schulz, 60 percent alc, 70 percent alc

Hapsburg, 72.5 percent alc, 85 percent alc, 89.9 percent alc

Havels, 60 percent alc, 70 percent alc

Herring Absenta, 50 percent alc

Huguet, 68 percent alc

King of Spirits, 70 percent alc

Krut's Karpor, 68 percent alc

L'Amesinthe, 45 percent alc

La Blanche, 57 percent alc

La Muse Verte, 68 percent alc

Larsand, 68 percent alc

Le 1924, 55 percent alc

Lehmann, 55 percent alc, 70 percent alc

Les Fleurs du Mal, 55 percent alc

Libertine, 55 percent alc

Logan Absinth, 55 percent alc, 70 percent alc

Manguin, 55 percent alc

Mata Hari, 60 percent alc

Montana Absenta, 55 percent alc

Neto Costa Absinto, 57 percent alc

New Pernod 68, 68 percent alc

Pére Kermann, 60 percent alc

Perla Vella, 69 percent alc

Prague Absinth, 70 percent alc

Provence, 55 percent alc

Rodnik's, 70 percent alc

Songe Vert, 66 percent alc

Staroplzenecky, 60 percent alc, 70 percent alc

Stromu, 70 percent alc

Tabu 55, 55 percent alc, Tabu 73, 73 percent alc

Tabu Red, 55 percent alc

Teichenne, 55 percent alc, 70 percent alc

Ulex, 55 percent alc, 70 percent alc

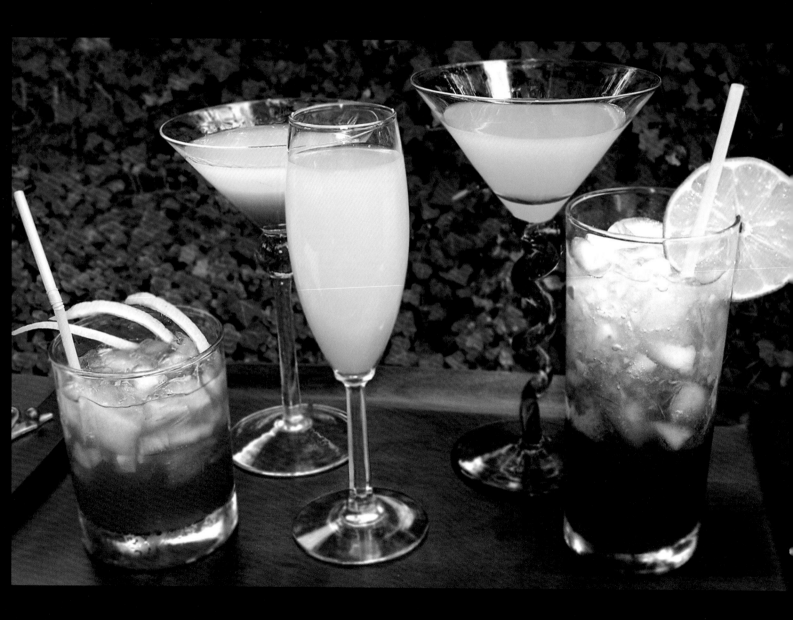

# CHAPTER 7

## *Toddies and Tastes*

### SPINS ON THE STANDARD SIP

Once the standard absinthe sipping methods have been mastered, you may want to familiarize your taste buds with various concoctions using the favored flavor. As with any mixed drink, the potency and swirled taste preferences vary from imbiber to imbiber. These recipes can be made with either true absinthe or any anise-flavored alchohol.

*Absent Days*
1 shot absinthe
2 spoonfuls of raspberry purée
½ shot peach schnapps
Dash of Gomme syrup and orange juice
    Shake and strain into cocktail glass.

(Opposite) Various absinthe-laden cocktails

*Absinthe Curacao Frappe*

1 shot absinthe

½ shot Curacao

Splash of lemon juice and orange juice

1 thin slice orange

    Stir ingredients and pour over crushed ice in a deep-saucer champagne glass.

*Absinthe Flip*

½ shot absinthe

½ shot Cointreau

Dash of lemon juice

1 small egg

Half a spoonful sugar

Grated nutmeg

    Shake ingredients well with ice. Strain into a pre-chilled glass. Sprinkle
    nutmeg on top.

*Absinthe Pit*

1 shot apricot brandy

1 shot apple brandy

½ shot absinthe

    Shake ingredients well with ice. Strain into a pre-chilled cocktail glass.

*Absinthe Suisse*

1 ½ shots Pernod

2 drops of absinthe

2 drops of orange-flower water

Splash with Crème de Menthe

1 egg white

    Shake with ice and strain into a cocktail glass.

*Bitch on Wheels*
2 shots gin
½ shot vermouth
½ shot White Crème de Menthe
1 dash of absinthe
　　Shake with ice and strain into a cocktail glass.

*Bloody Brain*
½ shot amaretto
1 shot absinthe
Grenadine
½ shot Bailey's Irish Cream
　　Pour amaretto first, then dribble absinthe down inside edge of the glass with a
　　spoon. Layering it on top of the amaretto, slowly pour Bailey's (with a spoon)
　　on top, letting it curl into a cloud on top of the amaretto. Sprinkle a couple of
　　drops of grenadine ("blood") on top. It should look like a brain floating in
　　formaldehyde (also known as a Brain Hemorrhage).

*Death in the Afternoon*
1 shot absinthe
Champagne to top off
　　Pour absinthe into a champagne flute and swirl it around to coat the sides.
　　Slowly pour the champagne to fill the glass.

*Earthquake Cocktail*
1 shot gin
1 shot bourbon
¾ shot absinthe
    Shake with ice and strain into a Collins glass.

*4th Estate Cocktail*
⅓ shot French vermouth
⅓ shot Italian vermouth
⅓ shot gin
4 dashes absinthe
    Layer in a shot glass.

*Hemingway Revolution*
1 shot absinthe
1 shot Chambord raspberry liqueur
½ shot Fraise
½ shot Crème de Cassis
Dash of cranberry juice
    Serve in martini glass with a sugared rim.

*Hemingway's Dream*
1 shot absinthe
½ shot lemon juice
3 cubes sugar
9 mint leaves
    Shake and strain into martini or cocktail glass.

*Honeydew*

1 shot gin

½ shot lemon juice

1 dash absinthe

2 oz (50 g) honeydew melon, diced

3–4 cracked ice cubes

Champagne, to top off

　　Place the gin, lemon juice, absinthe, and melon in a blender for 30 seconds.
　　Pour into a large wine glass, top off with champagne.

*Neptune's Descent*

1½ shots gin

1 shot vermouth

dash of orange bitters

1 dash absinthe

　　Shake and strain into cocktail glass.

*Ladies' Cocktail*

1½ shots Calvert Extra

2 dashes absinthe

3 dashes Anisette

1 dash bitters

　　Stir well with ice. Strain into glass. Serve with a piece of pineapple on top.

*L'Aird of Summer Isle*

3 shots pineapple juice

1½ shots Scotch whisky

½ shot absinthe

　　Shake and strain into a tall glass.

### Vinyl Sunset

1 shot absinthe
½ shot Cassis
Splash of lime
 Build over ice, top off with soda or lemonade.

### Voodoo Pigalle

2 shots absinthe
½ shot Midori
½ shot green Chartreuse
Dash of Gomme syrup
Splash of lemon juice
 Shake and serve.

### Whisky Daisy

Crushed ice
1 egg white (optional)
½ shot lemon juice
1 shot Scotch whisky
½ shot absinthe
2 dashes grenadine
Soda water to top off
Lemon rind to decorate
 Place ice into a cocktail shaker, add egg white, lemon juice, whisky, absinthe,
 and grenadine. Shake to mix. Pour into a tumbler, top off with soda water, and
 decorate with lemon rind.

**CULINARY ACCOMPANIMENTS**

Nothing compliments a complete absinthe table setting better than a decadent culinary spread. Delight your guests with dishes that do the Green Fairy's taste justice.

*Italian Canapé with Absinthe Sauce and Shrimp*
Toasted bread
1 small jar of mayonnaise
2 spoonfuls tomato sauce
1 teaspoon (5 milliliters) absinthe
½ teaspoon (2.5 milliliters) cumin
½ teaspoon (2.5 milliliters) curry
Frozen shrimp (precooked or ready to cook)
> Cut the bread into triangles. Mix the other ingredients together. Cook or heat up the shrimp, then set some aside for the decoration. Spread the sauce upon the bread and decorate each with one or two shrimp.

*Almond Delicacy*
3 cups (711 milliliters) thinly sliced almonds
2 cups (474 milliliters) chocolate
2 spoonfuls of coconut butter (or butter)
> Put the almonds in the oven and toast. Melt the chocolate with the coconut butter. When the chocolate is completely melted, mix the toasted almonds into it with a spoon and let it dry.

*Baci of Coconut*
½ (118.5 milliliters) cup sugar
1¾ (415 milliliters) cup minced coconut
2 egg whites
Juice of half a lemon
> Beat the egg whites with the sugar and lemon juice until you have a soft cream. Add the coconut and mix. Bake the mixture in the oven until slightly toasted. Serve with cookies or by itself.

*Canapé with Yogurt Sauce*
Toasted bread
1 small jar of yogurt
1 small jar of mayonnaise
½ tsp (2.5 milliliters) curry
Pinch of salt
> Cut the toasted bread in triangles and salt the pieces. Mix the yogurt (plain yogurt, not with fruit) with the mayonnaise and add curry. Spread this sauce upon the bread.

---

## CHAPTER 8

# *The Green Fairy Scene*

### BREAKING DOWN THE LAW

*A*s the whispers grow increasingly louder and the popularity of absinthe spreads its green fairy wings across the globe, it should be noted that true absinthe is still outlawed in some countries. While the lifestyle and ambiance that exudes from absinthe-inspired drinking establishments are indeed legal, the consumption of true absinthe is not always allowed. This is based on the prohibition of various compounds found in the drink, not necessarily thujone. The cataloging of the following Green Fairy scenes simply highlights places where either true absinthe or not-so-true absinthe is served.

### BRAZIL

Absinthe made its official Brazilian debut in October 2000, marking the first country in South America to legalize absinthe. The unveiling took place at a bar called Jatokas owned by Lalo Zanini, who's persistence was instrumental in bringing the Green Fairy to Brazil.

(Opposite) The famous La Fée green bus

**DRINKING SPOTS—BRAZIL**

*L'Absinthe*
Av. Hélio Pelegrino, 1170 Vila Olimpia
São Paulo, Brazil
(11) 3849-3663

*Absinto Club*
Rua Tutóia, 307 Jardins
São Paulo, Brazil
(11) 5561-6155

*Jotaka*
Avenida Pres. Juscelino Kubitschek,
201 Itaim Bibi
São Paulo, Brazil
(11) 3845 7272

With the publicity generated by magazines and newspapers, the first shipment of 1,200 cases was quickly sold. It seemed that everybody wanted to taste it as the news media spread across the country. Soon afterward, absinthe became popular with the hip and trendy set in Brazil.

At the height of popularity, a news report was aired on Brazilian television entitled "The Forbidden Drink Arrives in Brazil." The story was seen by millions of countrymen, many of which had never even heard of absinthe. The reporting journalists openly questioned the legality of the Green Fairy and started a controversy that made national headlines the next day.

Fearing all of this publicity, the Minister of Agriculture suspended all sales of absinthe until new analyses could be made. Bars that had purchased bottles were not permitted to serve it, however, this only served to pique the public's curiosity. People simply wanted to know facts and to decide independently of the reports and rumors. The future of absinthe in Brazil was in limbo.

Nonetheless, when the new technical inspections were completed, absinthe was legalized once again. Sales were remarkably large, partly because many had feared that it might be prohibited again. Absinthe, sold in upscale bars and restaurants at the rate of 28,000 bottles per month, has become one of the most popular drinks in the São Paulo, Brazil's nightlife scene.

## CANADA

Absinthe has made a very limited reappearance in certain parts of Canada, primarily British Columbia, Ontario, and Quebec. The Green Fairy was initially banned in 1912, but is now being allowed by the Liquor Board once again, given that the absinthes coming in to Canada contain low levels of thujone.

Hill's Absinthe is one such brand that has been approved because of its thujone level and is now quite popular. However it should be noted that the British Columbian absinthe champion is Vladimir Hill, who has family ties to Hill's Distillery in the Czech Republic. Nonetheless, Canadians are benefiting

from his promotion and may partake in the green drink in certain provinces, but it is by no means approved for all of Canada. Absinthe is working its way across the country, province by province.

## CHILE

In March of 1916, the importation of absinthe was prohibited in Chile. However, this prohibition was quietly nullified in 1928 when the article itself (which was intended to prohibit the importation of saccharine and obscene art) was repealed. Here's how the 1916 prohibition was worded (translated from Spanish):

National Finances Ministry Law #3066, Passed on March 1, 1916
Article 5: We hereby prohibit the importation of paintings, statues, figurines, books, or other objects that are obscene or whose nature contributes to the perversion of morals or proper behavior.
Article 6: We also prohibit the importation of:

1. The drink denominated "ajenjo" (absinthe)

2. Saccharine or related products … drinks or foods that contain saccharine or related products …

In short, from 1928 until today, absinthe has been legal in Chile. Nevertheless, it is not made, sold outside of cafés, or widely served there. The majority of Chileans have long since lost their taste for anis-flavored drinks. However, there is one café, located in a restored Belle Epoque mansion, which serves French absinthe, complete with spoons and fountains, to a small number of local connoisseurs.

**DRINKING SPOTS—CANADA**

*Lumiere Restaurant*
2551 W. Broadway
Vancouver, BC V6K 2E9
Canada
(604) 739-8185

*Pastis Restaurant Ltd.*
2153 West 4th Ave.
Vancouver, BC V6K 1N7
Canada
Phone: (604) 731-5020

**DRINKING SPOTS—CHILE**

*El Gran Café Berrí*
Rosal 321
Santiago, Chile

## CZECH REPUBLIC

In many places, absinthe is a well-hidden secret. This is not so in Prague. In the Czech capital, local brands of absinthe can be found in the menus of many cafés, and are often displayed in the windows of downtown delis and grocery stores.

Hill's Absinth, which was first created in 1920 and renewed after the fall of communism, became the largest-selling brand of absinthe in the world in the 1990s. Hoping to capitalize on the financial success of Hill's, numerous copycat brands have sprung up in the Czech Republic, many making claims with regard to thujone content to catalyze sales. Since the Czechs are not particularly fond of anise, however, Czech products tend to bear very little real resemblance to classic absinthe, although they do typically contain 55 to 70 percent of alcohol.

Despite its ubiquity in Prague, absinthe doesn't seem to be terribly popular with the larger Czech population, who generally prefer Slivovice (plum schnapps) or Becherovka, an herbal liqueur from Karlovy Vary. Czech absinthe appears to be more of a hit with Prague residents, tourists, and curious Germans or Americans who can be seen sipping the peculiar blue/green liquid in downtown bars.

Czech grocery stores carry a number of absinthe brands

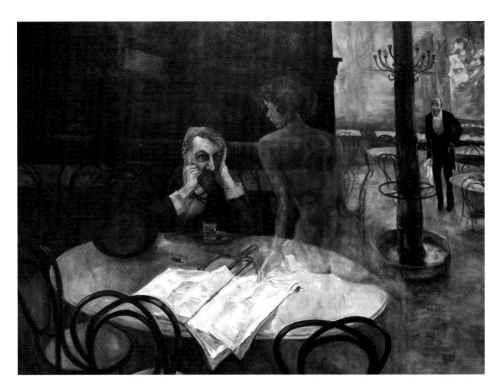

*The Absinthe Drinker* by Viktor Oliva, 1901
The painting hangs in Café Slavia

**DRINKING SPOTS—CZECH REPUBLIC**

*Café Slavia*
Smetanovo Nabrezi 2
2 1012, Prague
Czech Republic
(2) 2421-8493

*Radost FX*
Caf Belehradska 120
120 00 Prague
Czech Republic
(2) 2425-4776

*Dahab*
Dlouha 33
110 00 Prague
Czech Republic
(2) 2482 7375

*Café Imperial*
Na Porici 15
110 00 Prague 1
Czech Republic
(2) 2316 0121

**DRINKING SPOTS—FRANCE**

*Chez Ramulaud*
269 Rue du Faubourg St Antoine
75011 Paris
01 43 72 23 29

*Fontaine de Mars*
129 Rue St. Dominique
75007 Paris
01 47 05 46 44

*Le Café Zimmer*
1 Place du Châtelet
75001 Paris
01 42 36 74 03

*L'Absinthe Restaurant*
10 Quai de la Quarantane
14600 Honfleur
02 31 89 39 00

*L'Absinthe Bar at Montbrison*
1 Rue du Faubourg de la Madeleine
42600 Montbrison
04 77 58 4700

*La Table d'Eugène*
18 Rue Eugène Süe
75018 Paris
01 42 55 61 64

*Le Procope*
13 Rue de L'Anciènne Comédie
75006 Paris
01 40 46 79 00

## FRANCE

The climate and attitude toward absinthe in France is one that varies widely with respect to geography. In the region that surrounds Pontarlier near the Swiss border, absinthe can be found in the many cafés that lie in the sleepy towns, and is viewed by the regional residents as a curious tradition that provides their region with a distinctive identity. Many of them never adopted the 'absinthe is a poison' attitude.

From the early 1800s until 1915, Pontarlier was actively sustaining 150 bistros and twenty-three distilleries that exported vast quantities of the elixir across the globe. Even after its prohibition in 1915, the Green Fairy continued to impress private neophytes as well as expert collectors. Today, you may wander over to taste some absinthe at the distilleries of both François Guy and Emile Pernot, both of which are now producing absinthe. Each is a completely different atmosphere, so both should be experienced.

With the revival of a couple of brands of absinthe today that are made in the identical distilleries that produced them a century ago, there has been a great resurgence of interest by local collectors of absinthe accoutrements, such as fountains, glasses, spoons, carafes, match strikers, posters, and other advertising items. Given their close proximity to this historical epicenter, several local collectors have enjoyed particularly enviable success in obtaining some of the most rare and beautiful absinthe related items.

A must-see in France is the Pontarlier Museum, which features four large rooms of fabulous absinthe antiques. The gift shop has interesting posters, books, and cards. There one might meet one of the modern painters of absinthe related art, Michael Rousseau, whose modern absinthe paintings are now being reproduced in modern posters.

Next, visit the antique store of Patrice Cordier. The window is filled with absinthe antiques and wooden furniture along with ancient French paintings of renown. Patrice speaks English and has been selling antiques for more than twenty years. Besides being charming, he is filled with knowledge and will look for what you desire. He simply writes the request in a well-worn book.

While absinthe isn't viewed quite as favorably in other areas as it is in Pontarlier (due to the persistence of its sinister reputation), some brands are casually popping up in Parisian cafés and various popular drinking venues in other parts of the country.

**PONTARLIER ABSINTHIADES FESTIVAL**

The objectives of the Pontarlier Absinthiades Festival are to teach the public about the many different facets of absinthe and to recognize Pontarlier's historical relationship with the Green Fairy.

In the words of T. A. Breaux, "Upon entering the festival center, one finds perhaps a dozen or so private vendors of antique items, many of them related to absinthe. While most of the items on display can be had for the right price, by no means should one expect to find 'flea market' deals here. Perhaps most impressive was a generous display of some two-dozen assorted absinthe and post-absinthe fountains (which were not for sale).

Noted authors, such as Marie-Claude Delahaye, were vending autographed copies of their books. All in all, the event is one that is very casual and allows fellow collectors, authors, and enthusiasts to greet each other and converse in a relaxed atmosphere. English speakers should have functional skills in conversational French to get the most from this event. All things considered, the Pontarlier Absinthiades Festival is a small one, but the event is well organized, and the quality of the antiquities displays is unparalleled."

Advertising poster from Sixtina, Leipzig

## GERMANY

The German absinthe market is rooted in Berlin's younger crowd. However, absinthe bars can be found throughout Germany, in cities like Cologne, Leipzig, Karlsruhe, Hamburg, and Munich.

From 1998 through 2000, the most sold absinthe in Germany was Deva, but demands for other brands soon arose—Serpis and Tabu. In Germany, there exists no brand that is solely recognized above the others. Most people know of absinthe, but not by a specific brand name. People will offer that they drink absinthe, but they don't know specifically which one. Perhaps they know that it was green or red, but nothing beyond the color. But the need for brand distinction is growing.

Sixtina, Leipzig

**DRINKING SPOTS—GERMANY**

*Bar 11*
Wiener Str. 21
10999 Berlin
Kreuzberg
0177 50 51 325

*Druide Cocktail & Café Bar*
Schönhauser Allee 42
10435 Berlin
30 48 49 47 77

*Salmen Café Bar*
Waldstr. 55
76133 Karlsruhe
07 21 98 22 223

*Schwarzes Café*
Kantstr 148
10623 Charlottenburg
Berlin
49 30 313 80 38

*Sixtina*
Katharinenstr 11
04109 Leipzig
77 476 48 55

*Sonderbar*
Untere Str 13
69117 Heidelberg
6221 25200

*Terminal*
Durlacher Allee 4
76131 Karlsruhe
0721 6 64 97 19

**DRINKING SPOTS—SPAIN**

*Casa Almirall*
Joaquím Costa 33
Barcelona, Vizcaya
Spain
93 302-4126

*Bar Pastís*
Carrer Santa Mònica 4
Barcelona
Spain
93 318 79 80

*Benidorm*
Joaquím Costa 39
Barcelona
Spain

*Marsella Bar*
C. Sant Pau 65
Barcelona
Spain
93 442 72 63

*London Bar*
Carrer Nou de la Rambla 34
Barcelona, Vizcaya
Spain
93 318 52 61

## SPAIN

In Spain, the most historically significant region with respect to absinthe is the area around Barcelona. Producers like Teichenné, Montaná, Beveland, Depsa, and La Vallesana are currently established in the Barcelona area, but absenta producers can also be found in the neighboring areas of Valencia, Alicante, Murcia, Ibiza, and Mallorca.

Although absinthe was never formally banned in Spain, many of the old producers were confused about issues of legality. One prevalent union of the alcohol industry maintained that since the French law had declared it banned, absinthe was also forbidden in Spain. Although this law was not valid for Spain, most of the producers (with the notable exception of Montaña) were intimidated by the proclamations and ceased operations, closing their doors forever.

Because Spaniards tend to favor wine to anise liquors, only a few bars serve absinthe, most of these being located in tourist areas such as Barcelona. In liquor stores of Barcelona, the lesser quality brands can be found more easily, while the better Spanish brands are primarily intended for export.

**DRINKING SPOTS—UNITED KINGDOM**

*Alphabet Bar*
61-63 Beak St.
London W1F 9SL
020 7439 2190

*Alfreds* (Basement Bar AKA Dick's)
245 Shaftsbury Ave.
London WC2H 8EH
020 7240 2566

*Raffles Brown's Hotel*
Albemarle St.
London W1S 4BP
020 7493 6020

*Babuska*
40 St. Matthews Rd.
London SW2 1NL
020 7274 3618

*Barca*
Arch 8-9 the Arches
Manchester M3 4WD
01 61 839 7099

*Bed Bar*
310 Portobello Rd.
London W1O 5TA
020 8969 4500

*Something Blu*
317 Wilmslow Rd.
Manchester M14 6NW
01 61 248 0546

*Zeta Bar*
35 Hertford St.
London W1J 7SD
020 7208 4067

*Mojo*
18 Merrion St.
Leeds West Yorkshire LS1 6PQ
0113 244 6387

*Soshomatch*
2a Tabernacle St.
London EC2A 4LU
020 7920 0701

*The Lab Bar*
12 Old Compton St.
London W1V 5PG
020 7437 7820

*The Living Room*
80 Deansgate
Manchester Lancashire M3 2ER
0161 832 0083

*Reform Restaurant*
King St, Spring Gardens
Manchester Lancashire M2 4ST
0161 839 9966

*The Mac Bar*
102-104 Camden Rd.
London NW1 9EA
020 7485 4530

*The Player*
8 Broadwick St.
London W1F 8HN
020 7494 9125

*Pharmacy Bar Restaurant*
150 Notting Hill Gate
London W11 3QG
020 7221 2442

*The Fridge*
Town Hall Parade
Brixton Hill London SW2 1RJ
020 7326 5100

**SCOTLAND**

*Snug Bar*
75, Church St.
Dundee Angus DD3 7HP
01382 226978

*Air Organic*
36, Kelvingrove St.
Glasgow Lanarkshire G3 7RZ
0141 564 5200

*Valvona & Crolla*
19 Elm Row
Edinburgh
EH7 4AA, Scotland
0131 556 6066

*Oblomov*
372-374, Great Western Rd
Glasgow Lanarkshire
G4 9HT, Scotland
0141 339 9177

*Oloroso*
33 Castle St.
Edinburgh
EH2 3DN, Scotland
0131 226 7614

## UNITED KINGDOM

Not long after "absinth" began appearing in Czech venues, British entrepreneurs wasted little time in finding a way to import and distribute the Czech products into the United Kingdom with much fanfare and hype. The fashionable desire to be decadent resulted in U.K. bars offering Czech brands typically served as flaming shots at greatly inflated prices. Due to the nature of the marketing and lofty pricing for the rather  lackluster Czech brands, absinthe has remained largely a novelty drink. This may be changing to some extent, as some Spanish products and even more esteemed French absinthes have begun to appear in some better drink shops and bars.

**ABSINTHE AND U.S. LAW**

The importation and sale of absinthe is illegal in the United States. U.S. 21CFR172.510 prohibits the inclusion of Artemisia sp. as an additive in food products unless the final product is thujone-free as determined by using the official analytical method.

However, absinthe is not classified as a controlled substance in the U.S., although it is considered to be a prohibited item by U.S. Customs. In other words, while the simple possession of absinthe may not be illegal, the importation of absinthe into the U.S. technically is prohibited.

Antique absinthe fountain in the Old Absinthe House, New Orleans

Absinthe Brasserie and Bar, San Francisco

**DRINKING SPOTS—UNITED STATES**
*Absinthe Brasserie and Bar*
398 Hayes St.
San Francisco, CA 94102-4421
(415) 551-1590

*Cafe Absinthe*
1954 W North Ave.
Chicago, IL 60622-1318
(773) 278-4488

*The Old Absinthe House*
240 Bourbon St.
New Orleans, LA 70130
(504) 523-3181 or (504) 523-0103

*L'Absinthe Restaurant French Restaurant*
227 E 67th St.
New York, NY 10021
(212) 794-4950

## UNITED STATES

Although still prohibited in the United States, interest in the green muse has been simmering. This has been largely due to the advent of the Internet, which offers a variety of absinthe related websites where purchases can be made. Movies such as *Moulin Rouge* and *From Hell* have contributed to the fascination, and increasingly more people are now seeking this almost forgotten icon of the past. Bottles are being shipped in unmarked packages and private absinthe tastings and gatherings are happening in cities across the country. After nearly a decade since the birth of the modern absinthe revival, the stream of absinthe flows through the U.S., albeit does so relatively silently.

## ADDITIONAL WORLDLY
## ABSINTHE ESTABLISHMENTS

**DENMARK**

*Kruts Karport*
Øster Farimagsgade 12
2100 København Ø
35 26 86 38

**HOLLAND**

*Popl Nero Bar*
141, Nethergate
Dundee

*Angus*
DD1 4DP, Scotland
01382 226103
Netherlands

*Absinthe Night Bar*
Nieuwezijds Voorburgwal 171
Amsterdam, Netherlands
31 20 3206780

**HUNGARY**

*Potkulcs*
VI District Budapest
Csengery utca 65/B
269-1050

*Abzint*
1061 Budapest
Andrássy út 34
361 332 4993

**JAPAN**

*The Hub*
4-9-2 Roppongi
Minato-ku
Hoiyuza building 1F
Tokyo, Japan

*Bobby's Bar*
1-18-10 Milano
Toshima ku, Nishi Ikebukuro
Milano building 3F
Tokyo, Japan
03 3980 8875

*Hotel Okura, Tokyo*
2-10-4 Toranomon,
Minato-ku
Tokyo, Japan
81 3 3582 0111

**THE PHILIPPINES**

*Absinth Bar Café*
3rd Floor
Greenbelt 3 Ayala Center
Makati City, Metro Manila
Philippines

# *Appendix*

## VENDORS

Numerous sites offer absinthe and absinthe accoutrements for sale. But as afore-mentioned, please do some research about a vendor's reliability, absinthe quality, returns, shipping, and whether or not you are using a secured purchasing page.

### Absinthe Originals

P.O. Box 352
Esher
KT10 8ZE
United Kingdom
*http://www.absintheoriginals.com/*
*orders@absintheoriginals.com*
(fax) 44 (0)20 8398 8065

Absinthe Originals is dedicated to the sale of absinthe collectibles and Belle Époque barware. All of their items are guaranteed to come from the Belle Époque era, unless otherwise stated. They have a large collection of absinthe spoons and glasses available for sale. If you don't see what you want, ask—they may be able to obtain it.

### Allthingsabsinthe.com

Betina J. Wittels
www.allthingsabsinthe.com
*elixirs@flash.net*

Betina possesses a vast assortment of antique and modern objects of absinthe, along with her ability

to search for any absinthe object in the world. She is known for her thorough packing, customer service, and responsiveness to client requests. Her website contains a wealth of information about the golden age of absinthe, as well as paintings, antiques, and the history of fairies.

## Thomas Copin

*http://perso.wanadoo.fr/mahistaux/absinthe.htm*
*morphee@wanadoo.fr*

Thomas is a French collector and antiques vendor who has a passion for absinthe related objects. He wishes to export the Belle Époque spirit through his antique absinthe items.

## Patrice Cordier

Brocanteur-antiquaire
46, Rue de la Republique
25300 Pontarlier
France
03 81 39 50 19

Patrice Cordier has been the owner of an antiques store in Pontarlier for the past twenty years, and specializes in absinthe items. He speaks and understands English fairly well.

## eAbsinthe.com

P.O. Box 97
Hertford
SG13 8UD
United Kingdom
44 1992 511445
*www.eabsinthe.com*

This U.K. firm is a distributor for both Hill's Absinth and La Fée, and sells La Fée to both U.K. and international customers.

## La Boheme

4 Masons Ave.
Croydon
Surrey CR0 9XS
United Kingdom
44 77 6897 3304
*www.laboheme.U.K..com*
or
Slitrova 2013
190 16 Prague 9
Czech Republic
42 07 3255 0015

This firm sells a variety of Czech 'absinths,' and ships internationally.

## La Fée Verte

Absinth Import and Vertrieb

Neudorfstrasse 6c

79331 Teningen

Germany

49 7641 9359476

*www.lafeeverte.de*

*mail@LaFeeVerte.de*

> This German firm is very reliable, sells a variety of absinthes, and provides friendly service and speedy shipping to international customers.

## Liqueurs de France

40 Chestnut Ave.

Esher

Surrey, KT10 8JF

United Kingdom

44  20 8398 806

*www.absintheonline.com*

> This seller is a distributor of the Emile Pernot absinthes and gives friendly service and speedy shipping to international customers.

## Lucullus

Patrick Dunne and Kerry Moody

610 Chartres St.

New Orleans, LA 70130

(504) 528-9620

or

3932 Magazine St.

New Orleans, LA 70115

(504) 894-0500

*lucullus@bellsouth.net*

*www.neworleansseafood.net/Lucullus/lucullus.htm*

> Patrick and Kerry have long since established Lucullus as a leading source of French culinary objects and antiquities dating from the 1500s to the 1900s. Lucullus always seems to have an impressive selection of wonderful French culinary antiques and furnishings, and the owners and staff are unceasingly knowledgeable and helpful when furnishing/decorating advice is sought.

## Philipe the Frenchman

Philipe Fumoux

www.frenchmanltd.com

*frenchmanltd@wanadoo.fr*

> 'Frenchman' was the first to bring both modern and antique spoons, as well as other absinthe objects, to America via the Internet. He is known for both honest and trustworthy service. During the past year, his focus has shifted toward producing modern reproductions of the most famous spoons, including the Eiffel Tower, Toulouse-Lautrec, and so on. Though he speaks French, his English skills are quite functional.

**Sebor Absinthe U.K.**

P.O. Box 1111

Kingston upon Thames

Surrey KT1 4YX

United Kingdom

44 0 208 943 9526

*http://www.sebor-absinth.com/*

> This distributor sells the U.K. version of Sebor Absinth, both within the U.K. and to international customers.

**Steve Williams**

*www.absinthespoon.com*

*abspoon@yahoo.com*

> Steve offers a fine selection of high quality, modern reproduction absinthe spoons, glasses, and other miscellaneous items. He delivers fair prices, fast shipping, and guaranteed delivery. His selection changes periodically as new items are always being added.

**Wirthmore Antiques**

3727 Magazine St. and

3900 Magazine St.

New Orleans, LA 70115

*www.wirthmoreantiques.com*

(504) 269-0660 or (504) 899-3811

> Wirthmore Antiques specializes in eighteenth and nineteenth century French provincial antiques and collectibles with items celebrating all the best aspects of French culture.

## Select Websites

www.absinth.com
www.absinthebuyersguide.com
www.absinthe-literary-review.com
www.absintheonline.com
www.absintheoriginals.com
www.absintheradio.com
www.absintheworld.com
www.allthingsabsinthe.com
www.bestabsinthe.com
www.chem.ox.ac.uk
www.chez.com
www.eabsinthe.com
www.feeverte.net
www.geocities.com/SoHo/Nook/2689/absinthe.html
www.herbaut.de/bnoel/index.html
www.laboheme.cz/absinthe.htm
www.louchelounge.com
www.modbooks.com/absinthe
www.oldabsinthehouse.com
www.sebor-absinth.com
www.seborabsinth.cz/iindex.htm
www.sepulchritude.com
www.tabu-absinth.de

## Poster and Blotter Websites

www.authorizedart.com
www.ceruttimiller.com
www.inkblotters.com
www.internationalposter.com
www.posterfair.com
www.postermania2000.com
www.vintagepostersnyc.com
www.yaneff.com

**SELECT BIBLIOGRAPHY**

Baker, Phil. *The Book of Absinthe: A Cultural History.* New York: Grove Press, 2003.

Bataille, Christophe. *Absinthe: A Novel. Trans. Richard Howard.* Evanston, Ill.: Northwestern University Press, 1999.

Conrad, Barnaby. *Absinthe: History in a Bottle.* San Francisco: Chronicle Books, 1997.

Crowley, Aleister. *Absinthe: The Green Goddess.* Edmonds, Wash.: Holmes Pub Group, 1994.

Delahaye, Marie-Claude. *L'Absinthe: Art et Histoire.* Paris: Trame Way, 1990.

———. *L'Absinthe: Histoire de la Fée Verte.* Paris: Berger-Levrault, 1983.

———. *L'Absinthe: les Cuillères.* Auvers-sur-Oise: Absinthe Museum, 2001.

———. *L'Absinthe: Muse des Poètes.* Auvers-sur-Oise: Absinthe Museum, 2000.

———. *L'Absinthe: son Histoire.* Auvers-sur-Oise: Absinthe Museum, 2001.

Delahaye, Marie-Claude and Benoît Noël. *Absinthe: Muse des Peintres.* Paris: L'Amateur, 1999.

Lanier, Doris. *Absinthe the Cocaine of the Nineteenth Century: A History of the Hallucinogenic Drug and Its Effect on Artists and Writers in Europe and The United States.* Jefferson, N.C.: McFarland & Company, 1995.

Nelson, Aurealia. *Absinthe: Prosaic Bouts of Delirium.* Philadelphia, Penn.: Xlibris Corp, 2002.

Rimbaud, Arthur, Jean-Nicolas Rimbaud. *From Absinthe to Abyssinia: Selected Miscellaneous, Obscure and Previously Untranslated Works of Jean-Nicolas-Arthur Rimbaud. Trans. Mark Spitzer.* Berkeley, Calif.: Creative Arts Books, 2002.

(Top) *Plein Air* by Ramon Casas I. Carbo

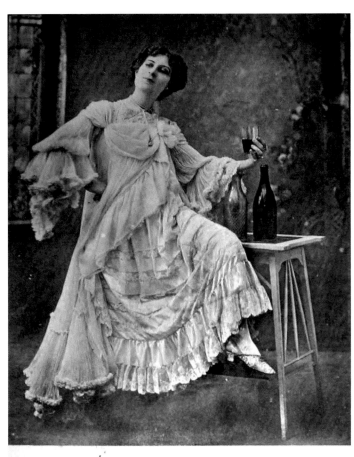

An absinthe ad for the Les Folies Theatre in Paris, the woman is saying, "I know how to prepare an absinthe"

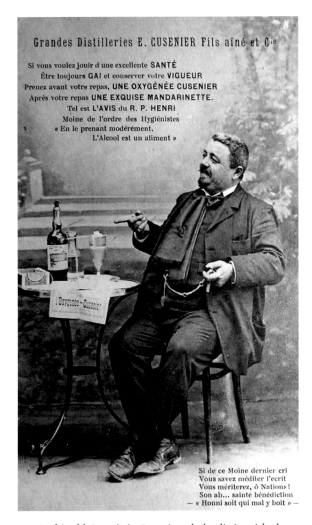

In this old Oxygénée Cusenier ad, the distinguished gentleman, content with cigar in hand and newspaper on the table, is stating that "if you want to be happy, drink a Cusenier absinthe."

## THE AUTHORS

Betina J. Wittels, M.S.Ed., co-founded a shelter for runaway children in 1976 and has maintained a private practice in adolescent, marital, and family therapy for more than two decades.

Sojourning on ships across the world, the gypsy wanderlust flows in her veins as she inscribes articles for several international travel guides.

As creator of the website, www.allthingsabsinthe.com, Betina was one of the first to formally introduce absinthe antiques and elegantly exalt the lore of the liquid to America. With her passion for life, she is willing to turn over any boulder in any cave or barrio to uncover a rare spoon or bottle of vintage absinthe.

In addition to historic libations, Robert Hermesch has a profound interest in Buddhist literature, cultural studies, deep ecology, and jazz. *Absinthe: Sip of Seduction* is the first of what he hopes will someday be several published works as he continues to study and refine the craft. Above all, Robert hopes the book will instill in its readers an insatiable thirst to explore more ethereal forms of self-reflection and further embrace relaxation as an art form, which he fears is rapidly fading in this country. Robert currently resides in Boston, Massachusetts, where he counsels disadvantaged youth.

T. A. Breaux is a professional scientist who has dedicated more than ten years of research toward resolving the mysteries associated with absinthe. His quest for the unadulterated truth has taken him across the globe in search of obscure, overlooked, and forgotten information circling this often maligned subject. Armed with a respectable background in applied analytical sciences, he has perfected sophisticated techniques for the purpose of accurately reconstructing the most famous original brands of the liquor (see www.bestabsinthe.com).

T. A.'s research has been recognized in numerous publications, and writers, researchers, and historians frequently seek his educated insight. He presently resides in New Orleans, Louisiana, and is the founder of the Société International d'Absinthe (www.lafeeverte.org), which is a rapidly growing worldwide organization that caters to absinthe connoisseurs.

*Absinthe Star Fall*, British illumination, 1270

# CREDITS

Title page: JBN Private Collection
Dedication page: JBN Private
Collection
iii: Marie-Claude Delahaye
ix: Marie-Claude Delahaye
x: Betina Collection
xii (top left): Betina Collection
xii (bottom left): T. A. Breaux
xiii: Private Collection
iv: Betina Collection

2: Benoît Noël
3: Private Collection
4: Betina Collection
5 (top right): T. A. Breaux and The Old Absinthe House
5 (bottom right): T. A. Breaux
6: Private Collection
7: JBN Private Collection
8: Betina Collection
9: JBN Private Collection
10: Crillon Importers, Ltd., The Atrium, 80 Route 4 East, Paramus, NJ 07652: Founded by legendary spirits master and marketer Michel Roux, the mastermind behind the Absolut, Stolichnaya, Grand Marnier, and Bombay Sapphire, Crillon Importers' imports ultra-premium brands from around the world and markets them in the United States and North America.
11: Betina Collection
12: Betina Collection
14: © Bettmann/CORBIS
15: © Leonard de Selva/CORBIS

17: © Archivo Iconografico, S. A./CORBIS
18: NY Carlsberg, Copenhagen
20: Private Collection
21: Private Collection
22: © Francis G. Mayer/CORBIS
26: © Bettmann/CORBIS
27: © Bettmann/CORBIS
28: © Bettmann/CORBIS
31: Private Collection
32: © Hulton-Deutsch Collection/CORBIS
35: © Bettmann/CORBIS
37: © Robert Eric/CORBIS SYGMA
38: © Marilyn Manson (via POSTHUMAN)
39: © Marilyn Manson (via POSTHUMAN)
41 (left): © Christina Radish/dita.net
41 (right): © Christina Radish/dita.net
42: © Reuters NewMedia Inc./CORBIS
44: JBN Private Collection
46: Betina Collection
48: Private Collection
49: Private Collection
50: © Swim Ink/CORBIS
51: Betina Collection
52: Betina Collection
54: T. A. Breaux and Lucullus
56 (top left): Betina Collection
56 (bottom left): Betina Collection
57 (top right): Betina Collection
57 (bottom right): Betina

Collection
58 (top left): Betina Collection
58 (bottom left): Betina Collection
59 (top right): Betina Collection
59 (bottom right): Betina Collection
60 (top left): Betina Collection
60 (bottom left): Betina Collection
61 (top right): Betina Collection
61 (bottom right): Betina Collection
62: Betina Collection
63: Private Collection
64: Private Collection
65: Betina Collection
66: Private Collection
67: Betina Collection
68: JBN Private Collection
69: JBN Private Collection
70: Private Collection
71: Private Collection
72: © Mark Meloche
75: T. A. Breaux
76: T. A. Breaux
77: T. A. Breaux
78: T. A. Breaux
79: T. A. Breaux
80: T. A. Breaux
81: T. A. Breaux
82: BBH Spirits
83: T. A. Breaux
84: T. A. Breaux
85: T. A. Breaux
86: T. A. Breaux
87: T. A. Breaux
88: T. A. Breaux
89: T. A. Breaux

90: T. A. Breaux
92: Speck Design
94: Speck Design
95: Speck Design
96: Speck Design
97: Speck Design
98: Speck Design
100: BBH Spirits
104: Ross Crockford
105: Ross Crockford and Café Slavia
108: Sixtina
109: Sixtina
111 (top center): Betina Collection
111 (bottom left): Betina Collection
111 (bottom right): Betina Collection
112: Betina Collection
114: T. A. Breaux and The Old Absinthe House
115: Absinthe Brasserie and Bar
117: BBH Spirits
124: Benoît Noël
125 (left): JBN Private Collection
125 (right): JBN Private Collection
127: Benoît Noël
130: Benoît Noël

# INDEX

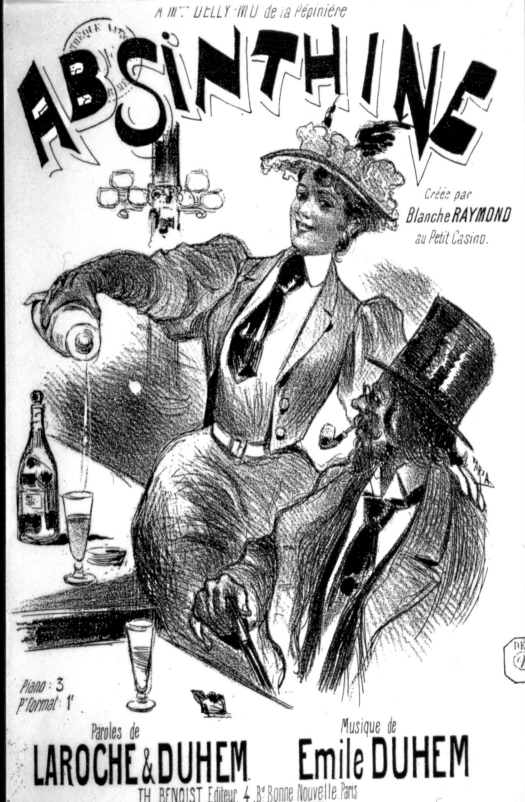